Images of Modern America

COLUMBIA
RIVER
GORGE
RAILROADS

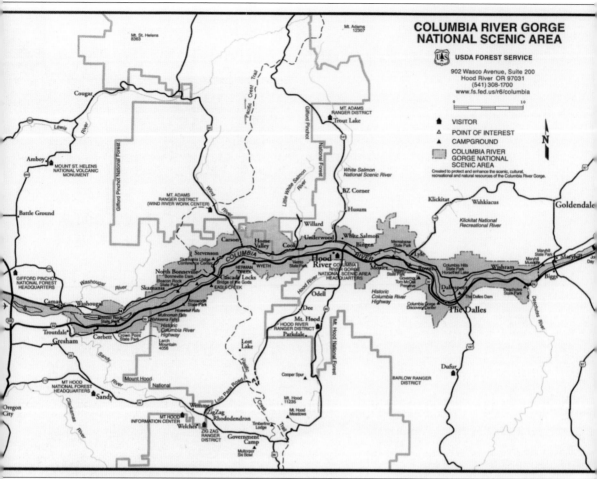

NATIONAL SCENIC AREA. The area shaded in dark green shows the boundaries of the 292,500-acre Columbia River Gorge National Scenic Area. The Columbia River separates the states of Oregon and Washington, with Washington north of the river and Oregon to the south. (Courtesy of the US Forest Service.)

FRONT COVER: With snow flying on a January day in 2008, a BNSF signal tower at West Bingen, Washington, displays a cautionary amber over red. (Photograph by D.C. Jesse Burkhardt.)

UPPER BACK COVER: A Union Pacific freight rolls westbound through majestic Columbia River Gorge scenery near Rowena, Oregon. (Photograph by D.C. Jesse Burkhardt.)

LOWER BACK COVER (from left to right): A kiteboarder races with the wind on the Columbia River near Underwood, Washington, as a Union Pacific container train passes behind him; Mount Hood Railroad No. 18 steams away at the historic depot in Hood River, Oregon; an eastbound BNSF grain train rolls past a bright patch of desert parsley. (All photographs by D.C. Jesse Burkhardt.)

Images of Modern America

COLUMBIA RIVER GORGE RAILROADS

D.C. JESSE BURKHARDT

ARCADIA
PUBLISHING

Published by Arcadia Publishing
Charleston, South Carolina

Printed in the United States of America

Library of Congress Control Number: 2015942839

For all general information, please contact Arcadia Publishing:
Telephone 843-853-2070
Fax 843-853-0044
E-mail sales@arcadiapublishing.com
For customer service and orders:
Toll-Free 1-888-313-2665

Visit us on the Internet at www.arcadiapublishing.com

To my Dad and Mom, Robert E. Burkhardt and Lois J. Burkhardt—
for raising three wild boys so well and always being there for us.

CONTENTS

ACKNOWLEDGMENTS

The author wishes to thank the following individuals who contributed to this book in various ways: Henry Clougherty and Sara Miller, editors at Arcadia Publishing, for being especially responsive and helpful and for trusting me to get it right; Kathy Fuller, Hillsboro, Oregon, for proofreading and insights; the staff of Pro Photo Supply, Portland, Oregon, for wonderful expertise and supplies; Elaine Bakke, publisher of the *Enterprise*, White Salmon, Washington; Marie Burkhardt, Aloha, Oregon; Clare Burkhardt, White Salmon, Washington; Oregon State Rep. Susan McLain, Forest Grove, Oregon; Diana Campos, US Forest Service, Hood River, Oregon; Darryl Lloyd, Long Shadow Photography, Hood River, Oregon; AshLee Wood and Kristen Ritter, Lantern Press, Seattle, Washington; Larry "Moon" Yaek, St. Clair, Michigan, for sharing the magic of Owosso on July 4, 1974; Greg Stadter, Phoenix, Arizona; Bob Dobyne, owner of Mirror Image Photos in Bingen and Dallesport, Washington; Chris Jaques, The Dalles, Oregon; Zach Tindall, Husum, Washington; Jim Tindall, Husum, Washington; Henry Balsiger, Snowden, Washington; Sophia Mathelier, Arcadia Publishing; Gus Melonas, BNSF Railway, Seattle, Washington; Michael Whiteman, Ashland, Oregon; Ben Seagraves, White Salmon, Washington; Olivia Passieux, Forest Grove, Oregon; Archer Mayo, White Salmon, Washington; Renae Cannon, Snowden, Washington; Tom Lacinski, Maple City, Michigan; Scott Sparling, Lake Oswego, Oregon; Leslie Jackson, White Salmon, Washington; Keith McCoy, Husum, Washington; all the railroad crews and support workers (including the crew-hauling drivers for PTI) who operate the rail network in the Columbia River Gorge; and my reliable and constant companion cameras over the years: first, a Pentax K-1000, and, later and currently, a Canon XSI.

INTRODUCTION

Railroads caught my spirit when I was a kid growing up near an east-west mainline in southern Michigan. The route that went past my boyhood home was a fast, modern Penn Central freight line that stretched from my hometown of Jackson, Michigan, to Elkhart, Indiana. There was something magical about standing alongside those tracks in Jackson, feeling the wind in my face and seeing the distant twinkle of an emerald signal light as the rails reached westbound toward an unknown horizon.

One summer, I experienced an unusual connection with the steel rails. On the afternoon of July 3, 1974, I was hiking in Owosso, Michigan, where an east-west mainline of the Grand Trunk Western (GTW) paralleled the tracks of the Ann Arbor Railroad. Only a short strip of tall weeds separated the two routes. With the July 4 holiday looming, the tracks of both carriers rested silent and still. As dusk approached, I cut through waist-high weeds, clambered up the GTW's roadbed, and looked to the west. There was a red signal shining in the distance—about a mile off, I figured; maybe a bit farther. As I stood on those height-of-summer tracks and gazed westward, that light seemed to hold me with a mystical pull. For long minutes, I could not take my eyes away from that deep red glow shimmering in the waves of heat radiating from the roadbed gravel. The sight was haunting and beautiful.

A year later, I pointed my 1967 Dodge Dart westward, following the tracks until I arrived at and eventually settled in a region I have come to love as much as my home state: the Columbia River Gorge of Washington and Oregon.

There is an old saying: "The only constant is change." In the Columbia River Gorge, change is truly eternal. The gorge was formed through a combination of volcanic activity and the "Missoula Floods," a series of cataclysmic floods at the end of the last Ice Age, about 15,000 years ago. These floods periodically rushed down the course of what is now the Columbia River and scoured out the gorge region, fashioning stunning, deep canyons and rocky landscapes in the process.

As spectacular as the scenery often is in the gorge, with its tall waterfalls and steep cliffs, a dramatic political event also forever altered the region's environment. In 1986, President Ronald Reagan signed the Columbia River Gorge National Scenic Area Act, which mandated the protection and enhancement of scenic, cultural, natural, and recreational resources in the gorge, as well as providing support for the region's economy. The act protected roughly 292,500 acres in an 85-mile-long corridor on both sides of the Columbia River. The territory stretches roughly from Troutdale, Oregon, and Washougal, Washington (at the National Scenic Area's western end), to Wishram, Washington, and Celilo, Oregon (to the east). The designated area is a land of scenic wonder revered by tourists and photographers for its natural beauty and by recreationalists for its fishing, kayaking, windsurfing, hiking, biking, and rafting.

The gorge is also home to two vital east-west rail routes. The first segment of the mainline tracks along the Columbia River in Oregon was completed in 1884 by the Oregon Railroad & Navigation Company, which later became part of Union Pacific Railroad. On the Washington side of the river, the Spokane, Portland & Seattle Railway opened its gorge mainline in 1908.

In the late 1950s, construction of dams on the Columbia River forced the relocation of long segments of the rail lines through the gorge, as the dams backed up the rolling river and flooded tracks that had been in use for decades. Also in the 1950s, the railroad industry itself underwent a major transition as the steam locomotive era came to an end. The end of steam operations brought a striking visual change as well, because colorful new diesel units replaced the venerable steamers, which were generally black. As a result, as the 1960s arrived, the trains gliding across the Columbia River Gorge countryside were literally imbued with a new coat of paint as motive power flooded through the area in a rainbow of colors.

By the early 1970s, the industry was going through yet another evolution, with railroad executives increasingly taking a hard look at the financial benefits of merging with other companies. Perhaps most notably, on March 2, 1970, there was a seismic shift with a direct impact on operations in the Columbia River Gorge. On that date, four railroads—the Great Northern; Northern Pacific; Spokane, Portland & Seattle; and the Chicago, Burlington & Quincy—combined to form one carrier, Burlington Northern (BN). The new railroad stretched across 25 states.

More than two decades later, in 1996, BN again transformed itself when it merged with the Santa Fe Railway, creating the modern-day Burlington Northern Santa Fe (BNSF). Not to be outdone, Union Pacific (UP)—BNSF's primary competitor in the modern era—engaged in a series of consolidations of its own. In 1982, UP acquired two railroads, the Missouri Pacific Railroad and Western Pacific, and followed that by merging the Chicago & NorthWestern in 1995, thereby expanding its territory and adding thousands of miles of track. In 1996, UP also took control of Southern Pacific, one of the West's biggest carriers. By the end of the mergers, UP stood as the nation's largest railroad, with nearly 33,000 miles of track spread across 23 states. BNSF was right behind, with roughly 32,500 miles serving 28 states.

On the other end of the scale, in a small corner on the Oregon side of the gorge, the Mount Hood Railroad has just 21 miles of track. The shortline operates a north-south line between Hood River, a tourist-oriented town on the Columbia River, and Parkdale, a small farming community. The Mount Hood line was built in 1906 to serve agricultural and logging businesses. For most of its existence, it has been an independent carrier. From 1968 until 1987, however, the railroad was operated as a Union Pacific branchline. In the late 1980s, when UP considered abandoning the line in response to declining freight traffic, private investors stepped in to keep the railroad working.

In 2008, Permian Basin Railways, a Chicago-based transportation holding company, bought the Mount Hood Railroad. As of 2015, the diminutive railroad still serves a few freight customers, while also offering a variety of popular passenger excursions year-round.

A photograph is, in essence, a time machine, and, with so much changing all around, the colorful images in *Columbia River Gorge Railroads* capture unique moments in time. Most of the chapters in this book celebrate the art and magic of the trains moving along this grand stretch of the Columbia River. Chapter three provides a wider, if brief, interpretive look at some of the people, places, and wildlife in this treasured land that has wisely been protected as a National Scenic Area.

In contemporary operations, dozens of freight trains, as well as Amtrak's daily *Empire Builder* passenger train in Washington, snake along on opposite sides of the wide Columbia River every day, pulsing across the terrain as a central part of the heartbeat of the gorge. BNSF is the owner of the mainline on the Washington side of the gorge, while Union Pacific reigns on the Oregon side. When it comes to hauling freight, the two railroad companies are the West's biggest competitors, and, if the photographs in these pages are any indication, the competition appears to be fierce.

Here is a glimpse of the action and the striking landscapes in which it takes place.

—D.C. Jesse Burkhardt
Snowden, Washington
December 2, 2015

One

WATER COLORS
THE WASHINGTON SIDE

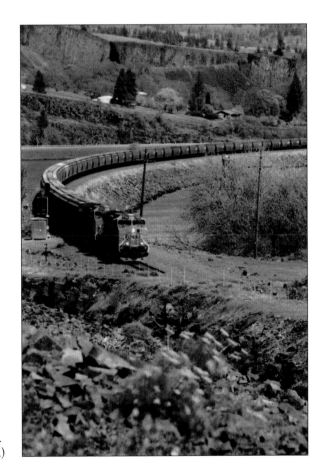

GRAIN HAULER. With bright yellow desert parsley blooming all around, a Burlington Northern Santa Fe grain train snakes westbound across Rowland Lake on its run to Vancouver, Washington. The lake is located about halfway between Lyle and Bingen on the Washington side of the Columbia River Gorge. Grain is one of the main commodities the railroad transports through the gorge. (Photograph by D.C. Jesse Burkhardt.)

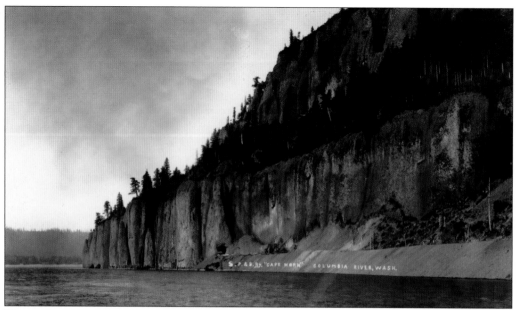

UNDER CONSTRUCTION. In 1907, crews were putting down tracks for the new Spokane, Portland & Seattle Railway (SP&S) mainline through the Columbia River Gorge. In this image, the right-of-way is being prepared near Cape Horn, a few miles east of where Washougal, Washington, is now located. The Cape Horn tunnel at this location is 2,382 feet long. (Collection of Henry Balsiger.)

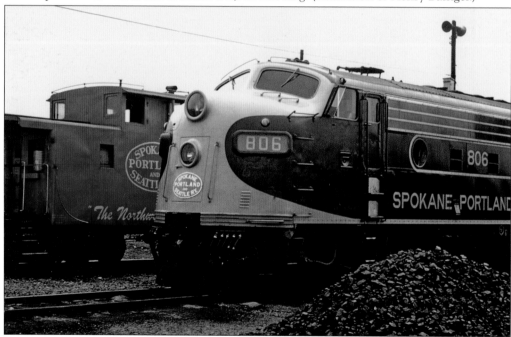

GATEWAY TO THE GORGE. The SP&S terminal at Vancouver, Washington, was essential to its operations in the Columbia River Gorge. Here, SP&S serviced locomotives and cabooses, crews began and ended their runs, and SP&S interchanged massive levels of tonnage with other railroads. In this 1960s photograph, SP&S F7A No. 806 rests on a ready track next to a red SP&S caboose bearing the company's slogan, "The Northwest's Own Railway." (Collection of Jerry Quinn.)

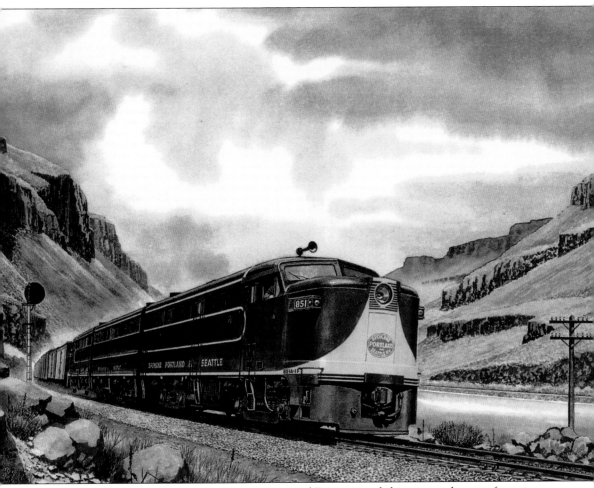

FAST FREIGHT TO PORTLAND. In 1988, artist Howard Fogg created this watercolor gem featuring a 1950s-era Spokane, Portland & Seattle (SP&S) Railway westbound freight train, led by SP&S Alco FA No. 851, roaring through the Columbia River Gorge near Wishram, Washington. Fogg, who served as a fighter pilot in World War II, specialized in railroad artwork throughout his career, creating approximately 1,200 paintings. He passed away in 1996 at the age of 79. This wonderful painting is representative of his beautiful, detailed work. (Collection of John De Filippis.)

TRANSITION IN VANCOUVER. A Spokane, Portland & Seattle Railway freight train pauses at Vancouver, Washington, in 1969. Just a few months later, in March 1970, the railroad became part of Burlington Northern. Vancouver was the western terminus of SP&S's Vancouver Division, which stretched 365 miles east to Spokane. (Collection of Michael Whiteman.)

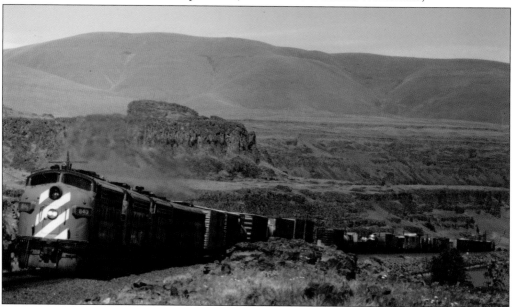

NOT MANY YEARS LEFT. Burlington Northern (BN) F9A No. 849 leads five "covered wagons" in charge of a westbound manifest at Horsethief Lake, a few miles west of Avery, Washington, in 1978. These 1,750-horsepower locomotives, built in the mid-1950s, were taken out of regular service in the early 1980s. (Photograph by Greg Stadter.)

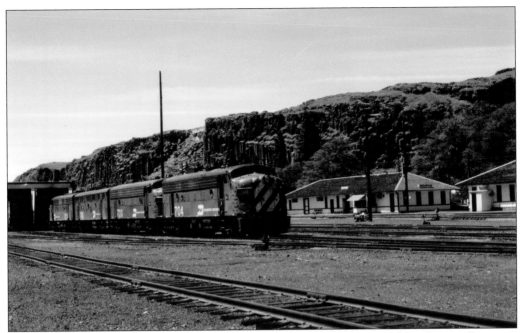

Resting at Wishram. Here, four clean locomotives rest on the ready track by the roundhouse at Burlington Northern's Wishram Yard in 1978. The building at far right was a railroad beanery that remained open 24 hours a day, 365 days a year for rail crews as well as the public. The restaurant closed in 1984 after 72 years in operation. (Photograph by Greg Stadter.)

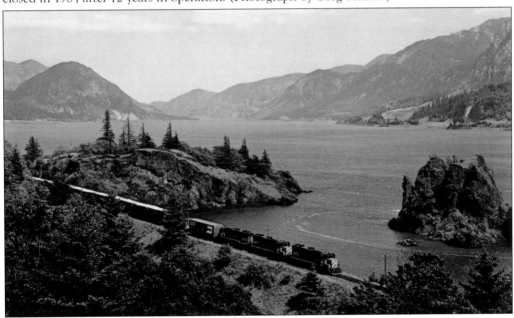

When GP38s Were New. The caption on the back of this postcard of a westbound freight train nearing Stevenson, Washington, notes that the train is being pulled by "a trio of the road's new GP38 locomotives." The GP38s were manufactured between 1966 and 1971, which helps to date this postcard. Since BN was not created until 1970, these units must have been among the final GP38s built. (Collection of D.C. Jesse Burkhardt.)

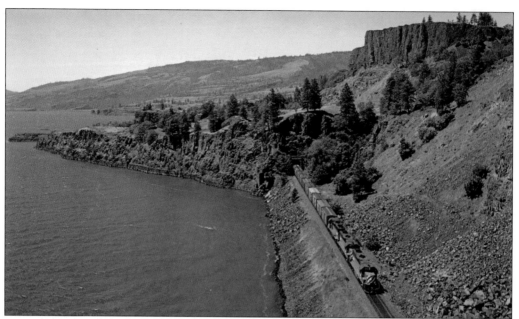

TUNNEL TIME. An eastbound Burlington Northern freight train emerges out of Tunnel No. 7, west of Lyle, Washington, in this 1971 postcard. On this section of track, trains go through four short tunnels in less than one mile: Tunnel No. 7 at milepost 82.8; Tunnel No. 8 at milepost 83.1; Tunnel No. 9 at milepost 83.3; and Tunnel No. 10 at milepost 83.5. (Collection of D.C. Jesse Burkhardt.)

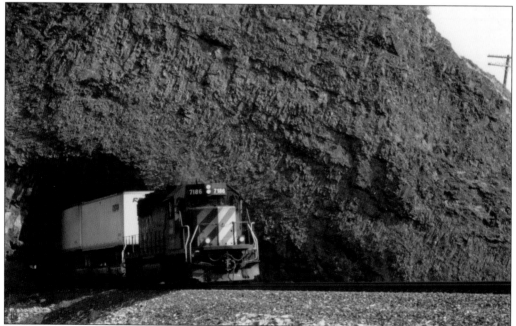

HARD ROCK. A westbound Burlington Northern intermodal train blasts out of the rock face of Tunnel No. 2 near Cooks, Washington, on the railroad's Fallbridge Subdivision, which runs from Wishram, Washington, to Portland, Oregon. It is October 1996, and BN has assigned a lone SD40-2 to power the train on its way to Vancouver. (Photograph by D.C. Jesse Burkhardt.)

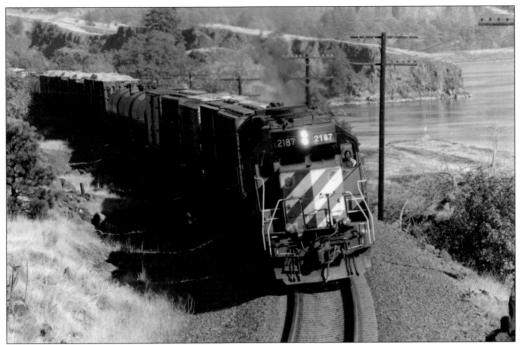

CONCRETE AND SILVER. Burlington Northern's mainline along the Columbia River has been maintained for swift, efficient operations, as demonstrated by the continuous welded rail and concrete ties on this stretch of track near Lyle. Leaning into a curve while headed west is BN GP38 No. 2187, running toward the crew's home base in Vancouver. (Photograph by Chris Jaques.)

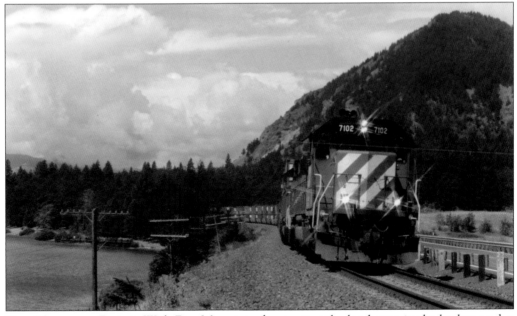

DOG MOUNTAIN RISING. With Dog Mountain dominating the landscape in the background, a BN trash train heads east on the railroad's mainline near Cooks in August 1995. The train is carrying Seattle-area refuse to the regional landfill at Roosevelt, Washington, another 83 miles down the line from Cooks. (Photograph by D.C. Jesse Burkhardt.)

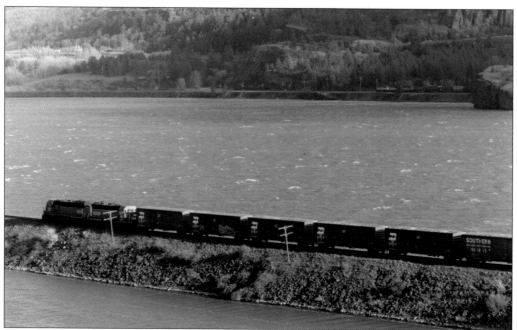

EASTBOUND RACERS. A Burlington Northern freight moves east on the Washington side of the Columbia River; across the river, on the Oregon side, a train operated by rival Union Pacific also moves tonnage eastbound. With the competing railroads running multiple trains every day, sights like this are not particularly rare. (Photograph by Chris Jaques.)

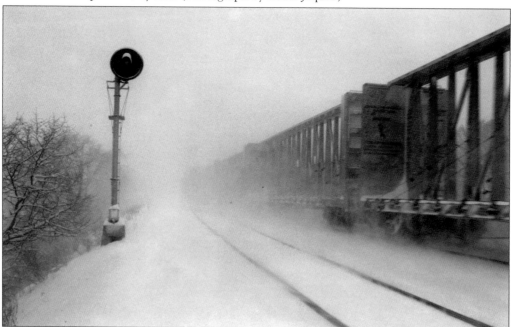

SNOW BLOWER. Clouds of snow kicked up by the fast passage of an eastbound mixed-merchandise freight swirl all around as the train rocks past a signal tower at milepost 76 in January 2004. The Columbia River Gorge typically gets one or two significant snowstorms each winter. (Photograph by D.C. Jesse Burkhardt.)

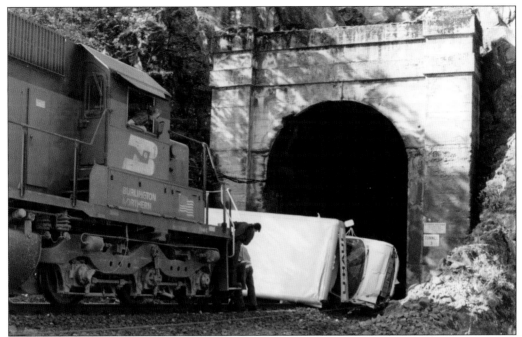

INCIDENT AT TUNNEL No. 3. On April 22, 1995, a driver in a U-Haul truck fell asleep while headed west on State Route 14 in Washington. The road parallels the BN mainline through the gorge. The truck went up the railroad embankment and overturned at the entrance to a tunnel. A westbound train, alerted in time to prevent a collision, was then employed to pull the truck away from the tunnel. The sleepy driver was not seriously hurt. (Photograph by D.C. Jesse Burkhardt.)

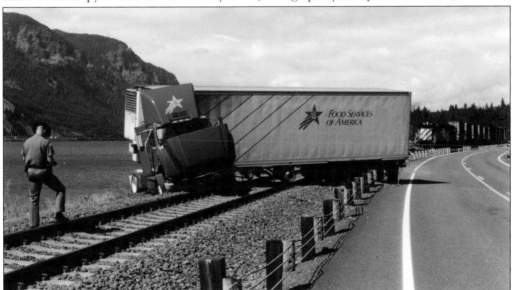

NOW HE HAS SEEN EVERYTHING. A Washington State Patrol trooper writes a report about a wild wreck on State Route 14. On August 11, 1995, the driver of a commercial tractor-trailer said his truck's wheels slipped off the roadway while he was reaching for a clipboard. The big rig went through a cable barrier and ended up on Burlington Northern tracks near Cooks. The accident held up trains for several hours. (Photograph by D.C. Jesse Burkhardt.)

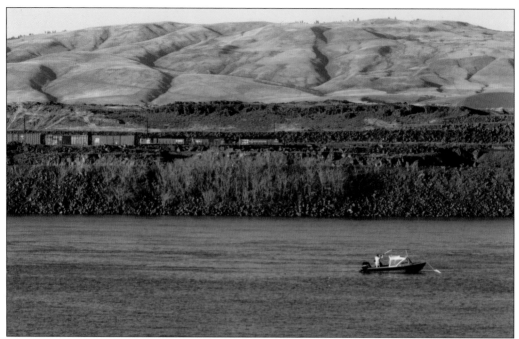

GOOD DAY FOR FISHING. In February 1997, two fishermen enjoy their sport on the Columbia River near Dallesport, Washington, while an eastbound BNSF freight rolls by on the river's northern shore. The combination of locomotives pulling the mixed-merchandise train includes an old-timer in the form of GP9 No. 1841, built in the mid-1950s. GP9 No. 1841 is working between 1980s-era GP50s No. 3110 and No. 3100. (Photograph by D.C. Jesse Burkhardt.)

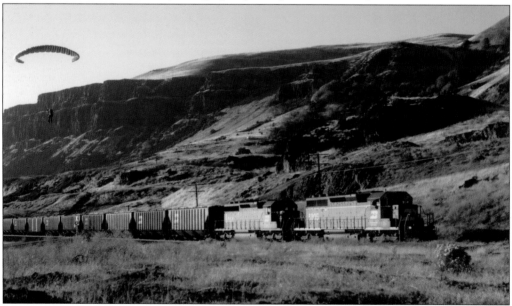

DROPPING IN. Paragliders drop from the sky above a stopped "eastbound empties" grain train at Avery, Washington, on November 16, 1996. Paragliding is popular in the Columbia River Gorge, because gliders can jump off the high bluffs and slowly descend to flat spots along the river. (Photograph by D.C. Jesse Burkhardt.)

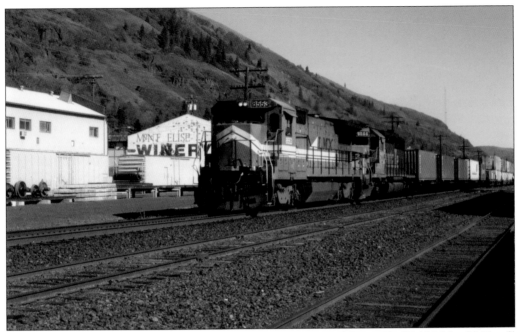

WINERY VISIT. A leased locomotive, LMX B39-8 No. 8553, and Santa Fe SD40-2 No. 5066 pull a stack train westward on BNSF rails on March 29, 1998. The train is passing the Mont Elise winery in downtown Bingen, Washington. The town was named after Bingen-on-the-Rhine, Germany. (Photograph by D.C. Jesse Burkhardt.)

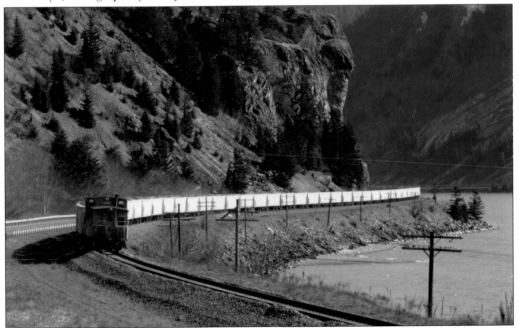

CABOOSE ON THE CURVE. Cabooses were rare on BNSF trains by the 1990s, although maintenance-of-way trains continued to use them. On March 11, 1999, BN No. 12431 is on the tail of an eastbound rock train placing fresh gravel along the BNSF roadbed in the Columbia River Gorge east of Home Valley, Washington. (Photograph by D.C. Jesse Burkhardt.)

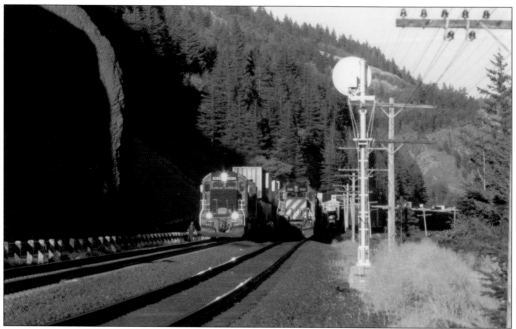

Z Train at Cooks. BNSF's hot United Parcel Service intermodal train, led by leased HLCX No. 6085, pauses on the western end of the siding at Cooks on September 29, 1998. The train is picking up two crewmen from a mixed-merchandise freight that parked on the siding to await a fresh crew. (Photograph by D.C. Jesse Burkhardt.)

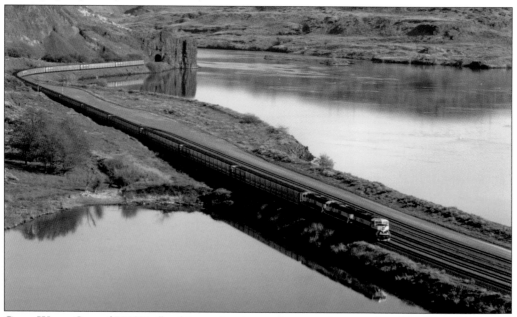

Coal West. One of BNSF's flagship coal trains snakes out of a tunnel on March 11, 1998, as it comes west through Wishram Yard. This is the innovative "Trough Train," with special long cars loaded in "troughs" so they could move more coal. Led by BNSF SD70MAC No. 9550, the train is on its way from the Powder River Basin in Wyoming to a power plant at Centralia, Washington. (Photograph by D.C. Jesse Burkhardt.)

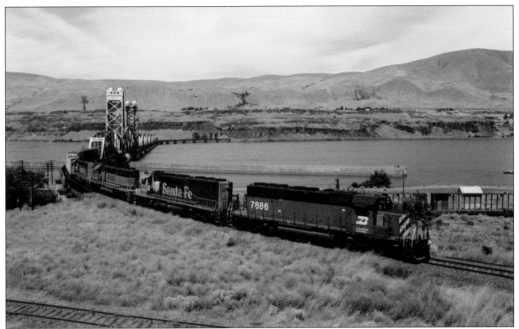

FREIGHT CROSSING. As it comes across the Columbia River Drawbridge between Wishram, Washington, and O.T. Junction, Oregon, a southbound BNSF freight passes above a Union Pacific freight rolling east on June 12, 1999. The BNSF train is headed down the Oregon Trunk Subdivision to the railroad's Klamath Falls Yard in southern Oregon. (Photograph by Zach Tindall.)

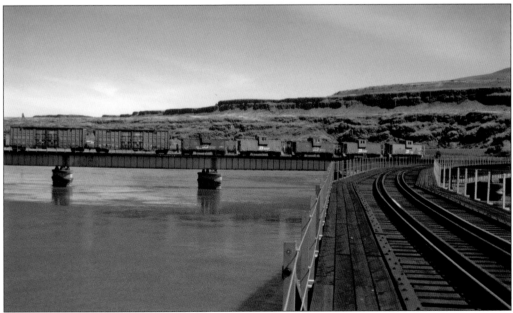

CALLING FOR CABOOSES. Until the late 1990s, operations on BNSF's Oregon Trunk Subdivision between Wishram, Washington, and Klamath Falls, Oregon, required cabooses. Much of the route lacked remote-control switches, so crewmen were positioned at the rear of trains to operate siding switches. In this June 8, 1997, image, five cabooses are crossing the drawbridge at Wishram, where they will be staged for southbound runs. (Photograph by D.C. Jesse Burkhardt.)

AMBER GLOW. Signal towers on the northern portion of BN's Oregon Trunk Subdivision—including this one pictured at Moody, Oregon, in June 1996—are constantly lit. The amber light shown here does not necessarily signify that an oncoming train is in the circuit. With this electronic configuration, the light always remains on, but the dispatcher changes the signal as needed when a train approaches. (Photograph by D.C. Jesse Burkhardt.)

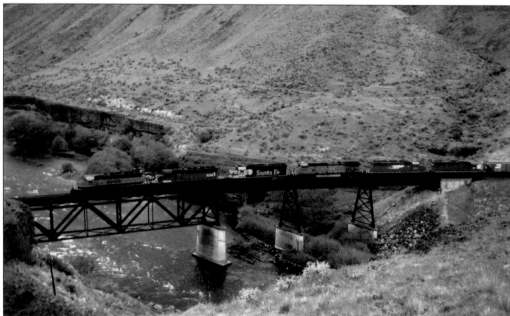

NO TWO ALIKE. Crossing a bridge over the Deschutes River near Sherar, Oregon, a mixed-manifest freight rolls south on BNSF's Oregon Trunk Subdivision behind six engines with six diverse paint schemes. The train, which left the Columbia River Gorge mainline at Wishram, Washington, just a couple of hours earlier on April 16, 2005, finds itself in the arid but equally beautiful Deschutes River canyon as it continues its run. (Photograph by D.C. Jesse Burkhardt.)

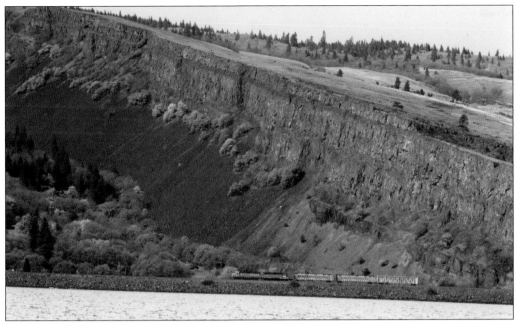

LOST IN THE LANDSCAPE. On April 16, 2003, BNSF's westbound Wishram Local passes the massive basalt rock edge of Washington's Burdoin Mountain. The Wishram-based train is hauling three empty centerbeam lumber cars to the SDS Lumber Company mill at Bingen. (Photograph by D.C. Jesse Burkhardt.)

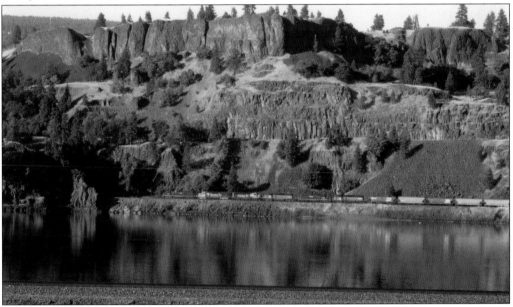

DISTANT RAINBOW. A mixture of locomotives on Burlington Northern Santa Fe Railway's Fallbridge Subdivision—the railroad's Columbia River Gorge mainline—provides a panoply of vivid colors, with three different paint schemes sprinkled among the six units. The locomotives are heading an eastbound general-merchandise freight train near Lyle on September 30, 1998. Union Pacific's Portland Subdivision mainline is in the foreground in this view. (Photograph by D.C. Jesse Burkhardt.)

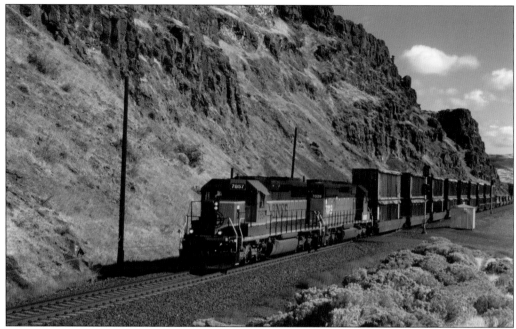

MARYHILL MAJESTY. Surrounded by the amazing rock cliffs of the Columbia Hills and a variety of native plants, a trash train out of the regional landfill at Roosevelt is shown coming and going as it rolls westward through Maryhill, Washington, on October 10, 2003. The long train is on its way through the Columbia River Gorge to Vancouver, where it will head north on BNSF's Seattle Subdivision to Seattle. There, the containers will be refilled and cycled back to Roosevelt within a few days. Two of BNSF's once-ubiquitous SD40-2s, No. 7857 and No. 7029, are in the lead on this run. (Both photographs by D.C. Jesse Burkhardt.)

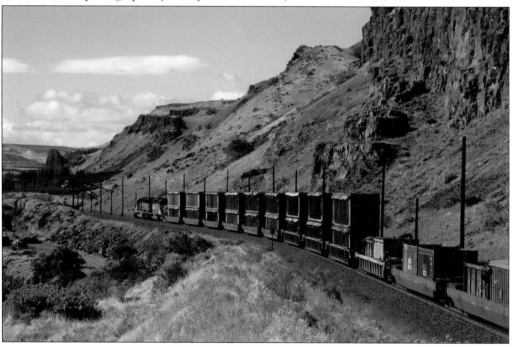

PACKED TRACKS. BN's freight yard at Wishram, near the eastern edge of the Columbia River Gorge National Scenic Area, is jammed with strings of freight cars and trains waiting to roll east, west, or south out of the yard on November 28, 1996. Plainly visible from the bluffs above Wishram is the Columbia River Drawbridge, which connects the railroad's Fallbridge Subdivision with the Oregon Trunk Subdivision. (Photograph by D.C. Jesse Burkhardt.)

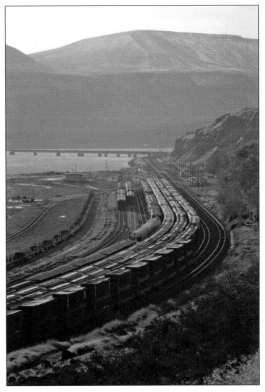

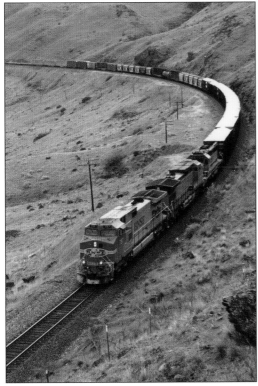

CANYON RUN. The steep slopes of Fulton Ridge rise alongside a northbound train on the Oregon Trunk Subdivision as it approaches Moody, Oregon, on March 23, 2002. The train, at this point about six miles from BNSF's Wishram Yard in Washington, is being led by ex–Santa Fe "Super Fleet" No. 757, which has been repainted in a BNSF scheme. (Photograph by D.C. Jesse Burkhardt.)

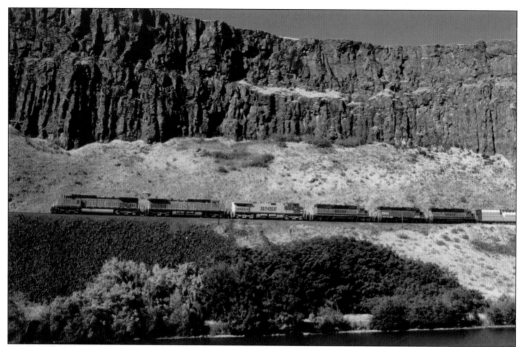

ALONG THE DESCHUTES. On July 3, 2004, six BNSF road engines in a mixture of paint schemes power a southbound freight on the railroad's Oregon Trunk Subdivision, which branches away from BNSF's Columbia River Gorge mainline at Wishram, Washington. The Oregon Trunk line follows the Deschutes River for 85 miles as it heads toward Klamath Falls. (Photograph by D.C. Jesse Burkhardt.)

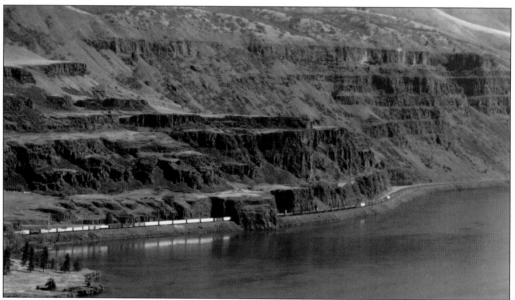

ROWENA GAP. Towering basalt cliffs dwarf a BNSF freight train rolling eastward along the Columbia River and into the area known as the Rowena Gap, east of the small community of Lyle. This photograph was taken from a lookout point near Mayer State Park on the Oregon side of the river. (Photograph by D.C. Jesse Burkhardt.)

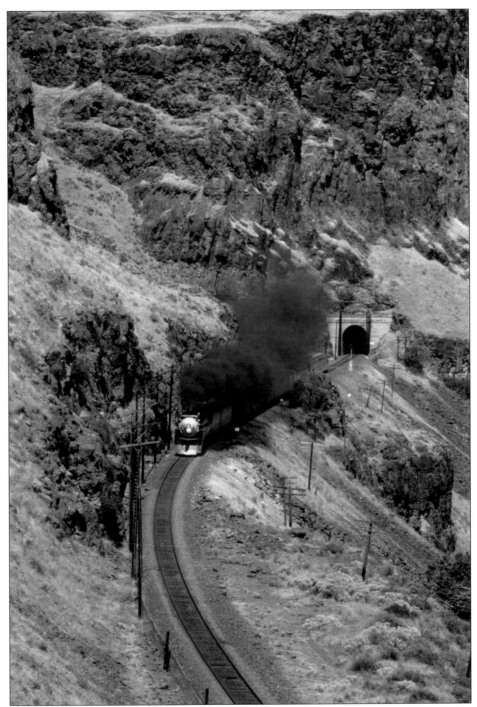

Smoking Out of the Tunnel. On its way from Wishram, Washington, to Sacramento, California, on June 12, 1999, Southern Pacific steam locomotive No. 4449, in its "Daylight" colors, smokes its way south at milepost 4 of BNSF's Oregon Trunk Subdivision near Moody, Oregon. The train includes three empty boxcars, added for braking purposes, as well as three passenger cars and a pair of support cars. (Photograph by D.C. Jesse Burkhardt.)

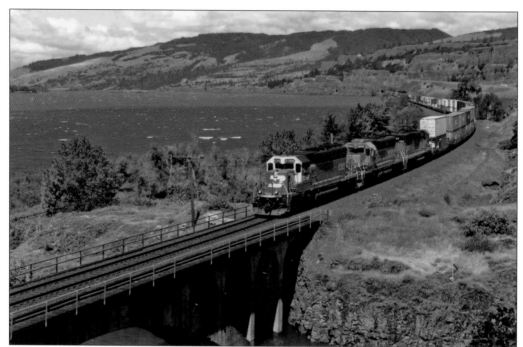

BRIDGE TO HISTORY. The Columbia River stretches out in the background, and bright wildflowers line the banks alongside the tracks, as BNSF eastbound freight trains cross an arch bridge over the mouth of the Klickitat River. The trains are moving containers in 1998 (above) and mixed merchandise in 2011 (below). The Klickitat River flows into the Columbia River at this point directly west of Lyle. The bridge was built in 1908 by the Spokane, Portland & Seattle Railway. The historic nature of the bridge earned it a listing in the Washington Heritage Register in 1981. (Both photographs by D.C. Jesse Burkhardt.)

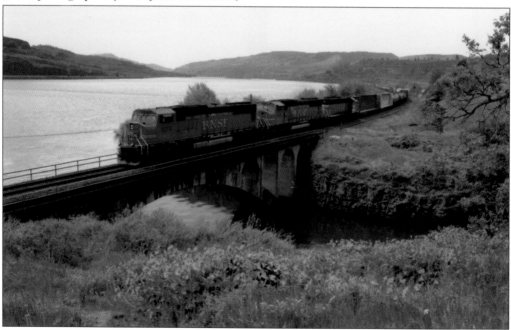

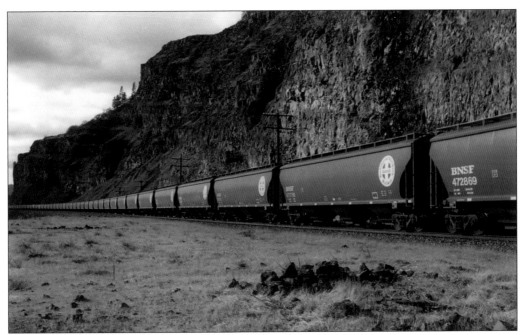

GRAIN STREAM. A unit train consisting entirely of new BNSF grain hoppers moves steadily westward through the gorge on its way to Vancouver, temporarily creating a virtual wall of grain cars. Each car can hold approximately 100 tons of grain, and 110-car trains are not unusual. (Photograph by D.C. Jesse Burkhardt.)

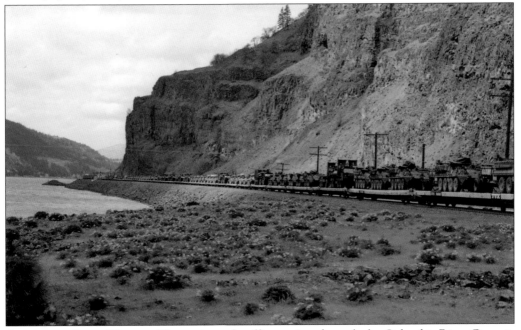

CONVOY ON STEEL WHEELS. The variety of traffic moving through the Columbia River Gorge is extensive. Even so, there are occasional surprises. On April 8, 2009, BNSF hauled this eastbound Department of Defense priority manifest: an entire trainload of flatcars loaded with military vehicles. (Photograph by D.C. Jesse Burkhardt.)

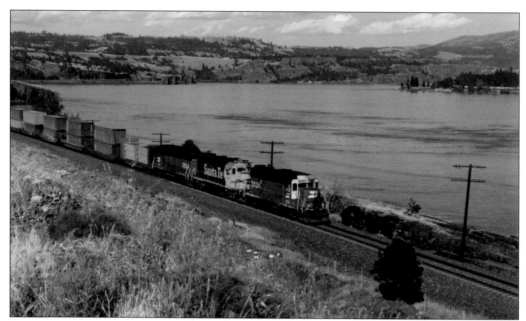

BLUE PARADE. With landfill owner Rabanco's telltale blue containers in tow, a Burlington Northern Santa Fe trash train from the regional landfill at Roosevelt, Washington, moves west with Seattle-bound empties behind a representative mix of Burlington Northern and Santa Fe power on April 25, 1998. The ability to share a larger pool of locomotives was one of the advantages of the 1996 merger of the two railroads. (Photograph by D.C. Jesse Burkhardt.)

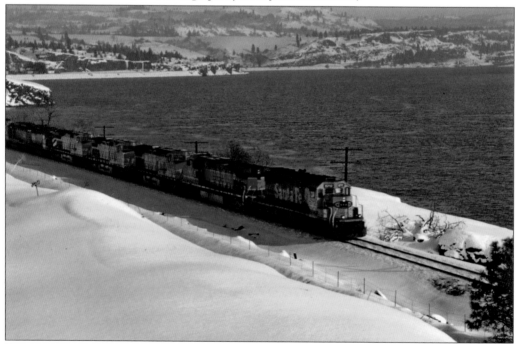

DRIFTING THROUGH THE SNOW. A long BNSF freight train glides westward through a pristine gorge snowscape in January 2004. Leading the way is Santa Fe SD40-2 No. 6712, which is setting the pace for an unusually lengthy cut of locomotives. (Photograph by D.C. Jesse Burkhardt.)

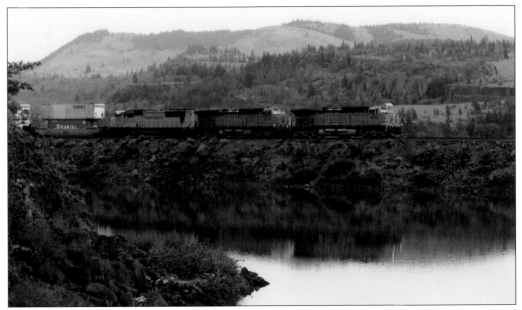

WESTBOUND REFLECTIONS. The reverse image of a westbound BNSF container train is captured here in a lake's surface. Although the train is running on BNSF's Fallbridge Subdivision, an engine from rival Union Pacific has been combined with two Burlington Northern Santa Fe units. (Photograph by D.C. Jesse Burkhardt.)

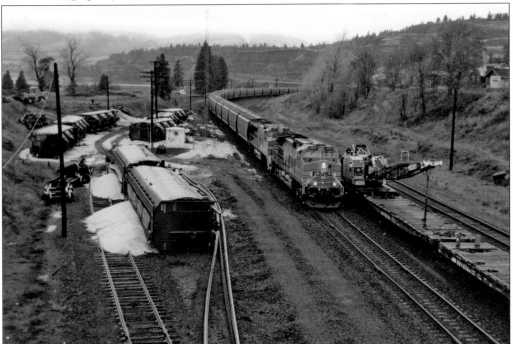

SPILLED GRAIN. Damaged grain hoppers rest on their sides in Lyle as a BNSF grain train heads east on January 22, 2003. Just two mornings earlier, 13 hoppers on a westbound train bound for Kalama, Washington, derailed here at a switch, spilling tons of grain. Despite the mess, the BNSF mainline through the gorge was only out of service for one day. (Photograph by D.C. Jesse Burkhardt.)

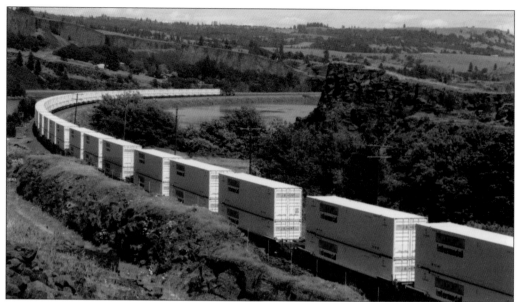

DOUBLE-STACK HEAVEN. Swinging into the big curve over Washington's Rowland Lake, two BNSF engines pull a full trainload of new, double-stacked containers eastward. The owner of the containers, Arkansas-based J.B. Hunt Transport Services, is one of the largest transportation-logistics companies in North America. The business describes itself as providing "safe and reliable transportation services to a diverse group of customers" in the United States, Canada, and Mexico. (Photograph by D.C. Jesse Burkhardt.)

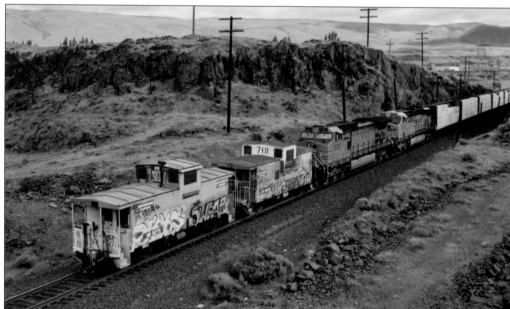

NOW KNOWN AS SHOVING PLATFORMS. Technological advances eliminated the need for cabooses, which were once standard at the end of freight trains. BNSF refurbished a few into "shoving platforms" to give crew members a safe place to watch for trouble during backing moves. On May 7, 2009, these two reconfigured cabooses—BN No. 10279 and Santa Fe No. 718—were going east at Dallesport, Washington. (Photograph by D.C. Jesse Burkhardt.)

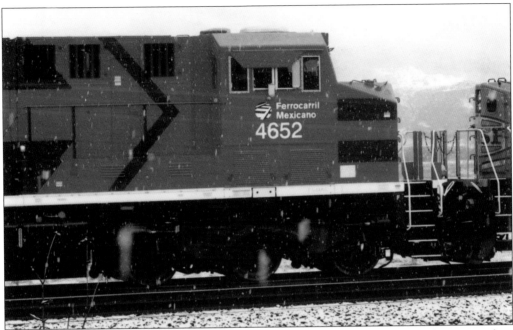

MEXICO IN THE GORGE. This new locomotive waiting on a siding at Bingen before proceeding west on February 24, 2007, might never have been in snow before visiting the Columbia River Gorge. The colorful engine, built by General Electric in December 2006, is owned by Ferrocarril Mexicano (Ferromex), Mexico's largest private rail consortium. Ferromex, based in Mexico City, began operations in February 1998. (Photograph by D.C. Jesse Burkhardt.)

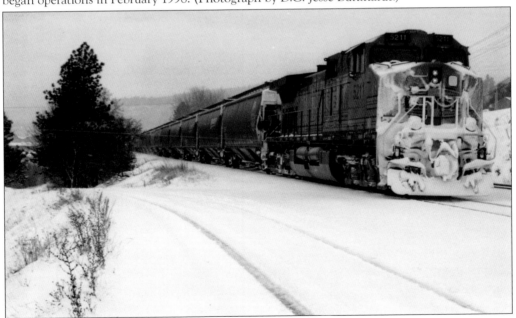

WHITE BEARD. While working at the rear of a westbound grain train on December 17, 2008, BNSF No. 5211 picked up a thick coating of snow and frost during its frigid run through a winter storm that blasted the gorge. The locomotive is shown here leaving the siding at Bingen. (Photograph by D.C. Jesse Burkhardt.)

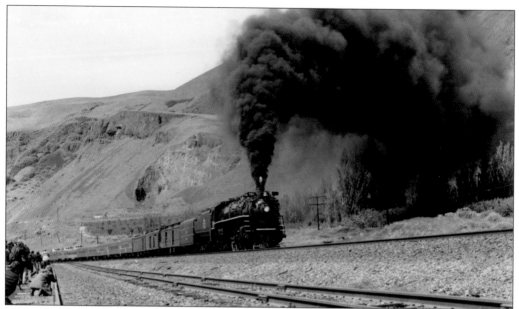

MEMORIES OF STEAM. Enthusiasts crowd the tracks near Wishram to photograph Spokane, Portland & Seattle Railway No. 700, which was on a special "Back to Home Rails" excursion between Vancouver and Spokane on April 20, 2001. The locomotive was built by Baldwin Locomotive Works in Pennsylvania and delivered to SP&S in 1938. Until it was retired in 1956, the steamer was primarily used in passenger train service. (Photograph by Chris Jaques.)

BOUND FOR GLORY. Southern Pacific No. 4449—briefly back in its "American Freedom Train" colors for a special run to honor victims of the September 11, 2001, terrorist attacks—is pictured on March 23, 2002, on the Oregon Trunk Subdivision a few miles south of Wishram, Washington. It fades into the landscape trailing a plume of steam. Lima Locomotive Works of Lima, Ohio, built the venerable machine in 1941. (Photograph by D.C. Jesse Burkhardt.)

Two

TRUCKIN' BY TRAIN
THE OREGON SIDE

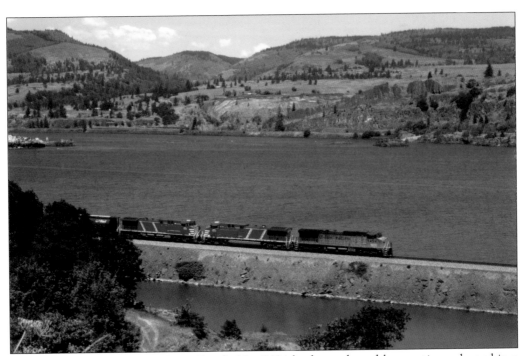

ROLLING WITH THE BLUES. Union Pacific No. 9404 leads two leased locomotives adorned in a colorful paint scheme that matches the deep blue of the Columbia River stretching out behind the train. The units are hauling an eastbound soda ash train across a levee near Oregon's Memaloose State Park in the heart of the Columbia River Gorge. (Photograph by D.C. Jesse Burkhardt.)

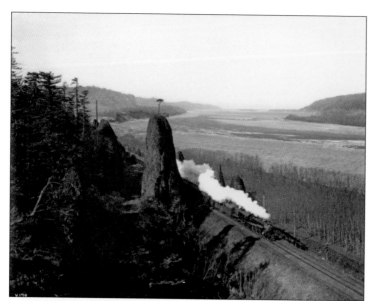

STEAMING PAST THE PILLARS. A Union Pacific passenger train trails a white plume of steam as it heads east past the "Pillars of Hercules," two towering basalt columns west of Bridal Veil, Oregon. When the Oregon Railroad & Navigation Company built the rail line through the gorge in 1884, the tracks went between the columns, but UP relocated the line to the north side of the pillars sometime around 1913. (Collection of Curtis Culp.)

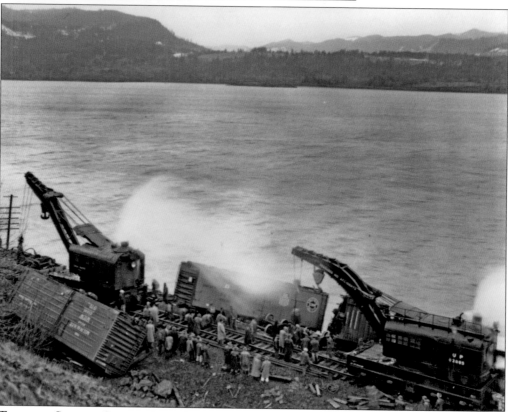

TAKING A SLIDE IN STRIDE. According to the Salem, Oregon, newspaper *Daily Capital Journal*, a 92-car eastbound Union Pacific freight train hit a mudslide near Cascade Locks, Oregon, on February 21, 1954, derailing a locomotive and nine cars. There were no serious injuries to any of the train's crew, and workers with steam cranes reportedly cleared the wreckage and reopened UP's Columbia River Gorge mainline the same day. (Collection of Curtis Culp.)

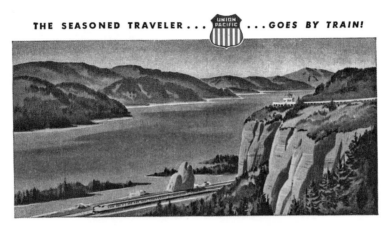

Seasoned Traveler. In the 1950s, American railroads used advertising campaigns to encourage travelers to ride on their trains. Union Pacific enjoyed a marketing edge, because it could offer the scenery of the Columbia River Gorge. This colorful advertisement shows one of UP's passenger trains rolling through the gorge near Crown Point, Oregon. The text entices the reader: "Entering the Pacific Northwest, your route parallels the magnificent Columbia River Gorge for 200 miles. A marvelous scenic panorama." At a time when airlines and cars were drawing customers away from trains, the advertisement's headline cleverly suggests that sophisticated people prefer trains to other modes of travel: "The seasoned traveler . . . goes by train!" (Collection of D.C. Jesse Burkhardt.)

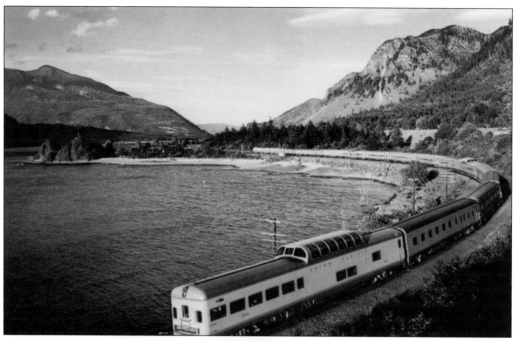

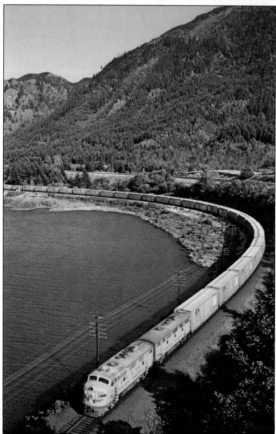

MILES OF TREES AND RIVER. A colorful postcard depicting a Union Pacific passenger train in the mid-1950s puts a spotlight on the beautiful scenery in the Columbia River Gorge. The postcard shows a shiny eastbound *City of Portland*, which appears to be in the vicinity of Cascade Locks, and the caption on the back adds seductive promotional imagery: "Your eyes drink in the ever-changing panorama through wide windows of UP domeliners." (Collection of D.C. Jesse Burkhardt.)

BOXCARS ON PARADE. Union Pacific also featured the gorge when advertising its freight service. In this UP postcard from the early 1960s, the caption indicates that "a train of all new yellow boxcars" is heading westward through the same scenic location as the passenger train shown in the image at the top of this page. The boxcars pictured here have the popular "Automated Rail Way" four-color map and logo painted on the sides. (Courtesy of Union Pacific Railroad.)

SCENIC ROUTE. This detail from Union Pacific's 1994 national route map highlights its mainline through the Columbia River Gorge. Known as the railroad's Portland Subdivision, the east-west route stretches 185 miles, from Portland to Hinkle, Oregon. (Courtesy of Union Pacific Railroad.)

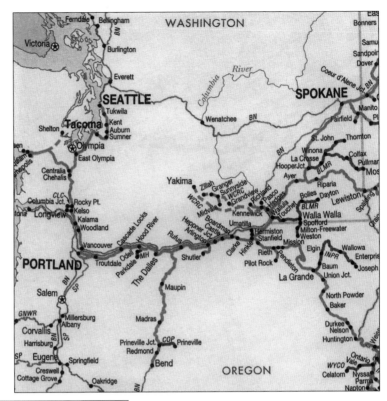

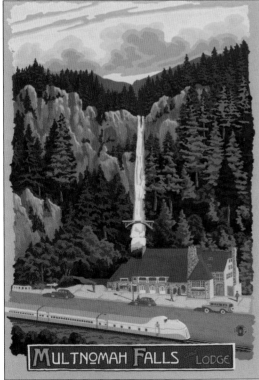

MULTNOMAH FALLS. A beautiful greeting card from Lantern Press of Seattle, Washington, offers a stylized glimpse at a key Columbia River Gorge attraction— Oregon's Multnomah Falls. Union Pacific started its *City of Portland* streamliner passenger train service in 1935. For several decades, trains stopped at Multnomah Falls on runs between Portland and Chicago. The rustic lodge in front of the famed 620-foot waterfall was built in 1925. (Courtesy of Lantern Press.)

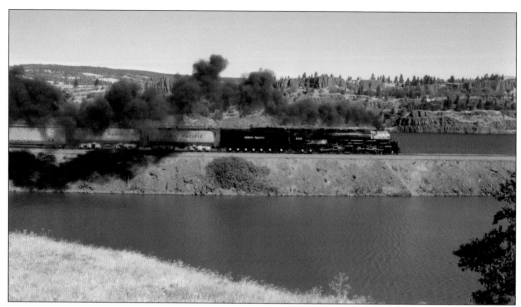

HISTORY IN THE GORGE. On September 22, 2005, UP No. 3985, a 4-6-6-4 "Challenger" locomotive, steamed east through the Oregon side of the Columbia River Gorge. The historic coal-burning steamer was built by the American Locomotive Company (Alco) in 1943 and retired in 1959. UP restored it in 1981, converting it into an oil-burner in the process. (Photograph by D.C. Jesse Burkhardt.)

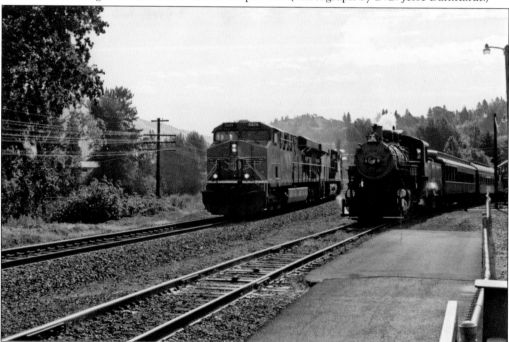

ALMOST A CENTURY BETWEEN THEM. A westbound Union Pacific freight train zooms through Hood River, Oregon, just as a Mount Hood Railroad steam locomotive is inching up to the depot to load passengers for an excursion run on August 31, 2007. Leading the UP train is No. 5406, a high-tech unit built in 2005, while Mount Hood's No. 18 was built in 1910. (Photograph by D.C. Jesse Burkhardt.)

CENTENNIAL CELEBRATION. On May 10, 1869, the legendary "golden spike"—a ceremonial railroad spike made of gold—was tapped into place at Promontory Summit, Utah, to formalize the connection of the Central Pacific and Union Pacific railroads, thus completing the country's first transcontinental rail line. A telegram then went out to President Ulysses S. Grant, and its message was as dramatic in its time as was the first landing on the moon in a later generation: "The last rail is laid! The last spike is driven! The Pacific railroad is completed. The point of junction is 1,086 miles west of the Missouri River, and 690 east of Sacramento City." A century later, at a salute to the historic event, Union Pacific officials announced the purchase of 25 "Centennial" locomotives, like this one featured in a commemorative brochure. (Collection of Jim Tindall.)

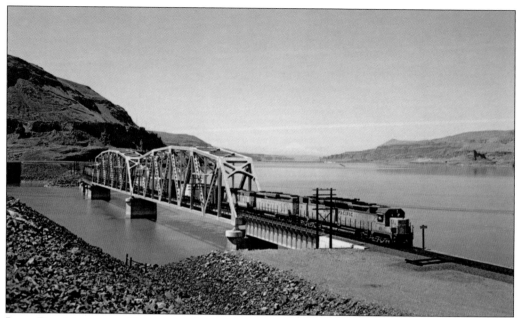

JOHN DAY MEETS THE COLUMBIA. A promotional postcard produced by Union Pacific shows a freight train crossing the John Day River where it connects with the Columbia River. The bridge is about 10 miles east of Biggs, Oregon, and is just outside what is now the Columbia River Gorge National Scenic Area. Oregon's Mount Hood is faintly visible in the background just above the locomotives. (Courtesy of Union Pacific Railroad.)

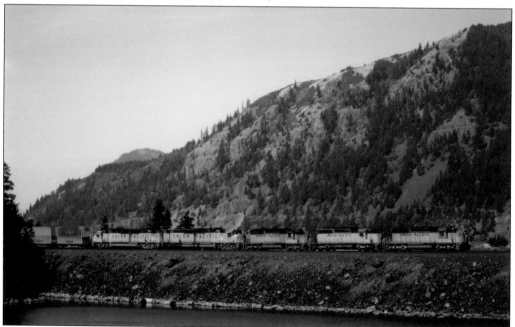

ACTION AT LINDSEY LAKE. In this image from September 1984, UP No. 3463 is in the lead of five locomotives, including two of the venerable Centennials, pulling a container train eastbound past Lindsey Lake near Viento, Oregon. In the background, on the other side of the Columbia River, is Washington's 2,948-foot-high Dog Mountain. (Photograph by Greg Stadter.)

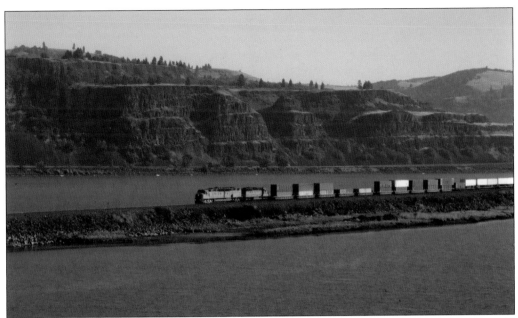

COULD NOT STAY RETIRED. Union Pacific found itself with more tonnage to move than it could efficiently handle after absorbing Southern Pacific in 1996. As a result, the railroad brought a popular old-timer out of storage and put it back to work. On October 25, 1997, UP DDA40X No. 6936, with an assist from SD40-2 No. 3766, led a westbound stack train (above) nearing Mosier, Oregon. Later the same day, the 6,600-horsepower locomotive passed through Cascade Locks (below) as it continued its run. UP bought 47 of the big locomotives, which were built by the Electro-Motive Division of General Motors between 1969 and 1971. (Both photographs by D.C. Jesse Burkhardt.)

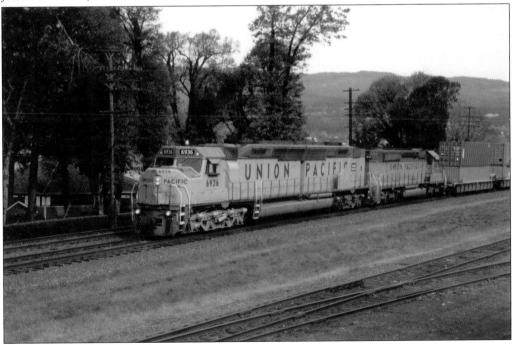

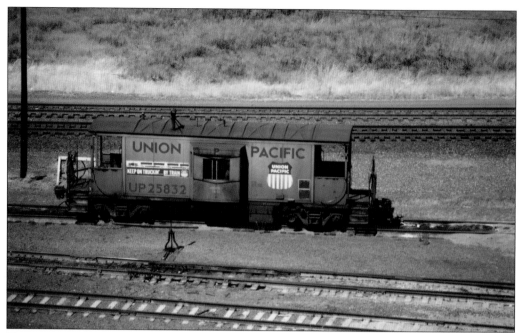

TRUCKIN' BY TRAIN. Union Pacific caboose No. 25832 rests in the UP freight yard at The Dalles, Oregon, in August 1996. The caboose was required for a Union Pacific local operating between The Dalles and Bend, Oregon. The slogan on the side of the caboose recalls a time when railroads seemed to be more aggressive in their marketing efforts: "Keep on truckin' . . . by train." (Photograph by D.C. Jesse Burkhardt.)

CONVERGENCE. Locomotives with diverse histories assemble in the UP freight yard in The Dalles on March 5, 1997. Included in the panoply of colors is Southern Pacific SD45T-2 No. 7430, featuring the aborted SP/Santa Fe merger paint scheme. (Photograph by D.C. Jesse Burkhardt.)

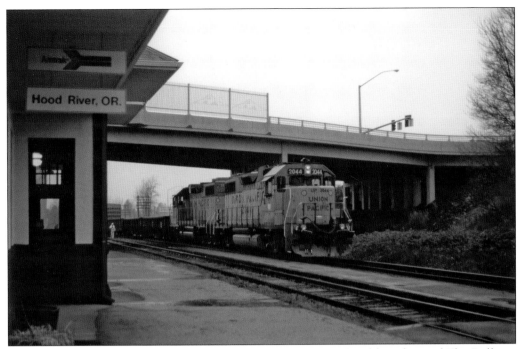

WORKING IN THE WET. On a rainy day in January 1999, a UP local based out of The Dalles is switching in Hood River in front of the historic depot that serves as the Mount Hood Railroad's headquarters. The Amtrak sign hanging from the station was obsolete, as Amtrak's *Pioneer*, which operated between Seattle and Chicago via Portland and the Columbia River Gorge, had ended service in 1997. (Photograph by D.C. Jesse Burkhardt.)

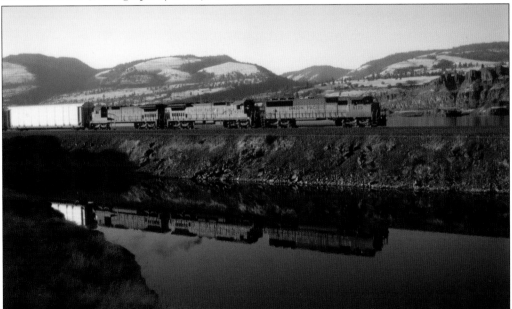

DOUBLE VISION. As the sun drops low in the west on September 30, 1998, a train of eastbound auto-racks is vividly reflected in the calm water of McClure Lake near Memaloose State Park. (Photograph by D.C. Jesse Burkhardt.)

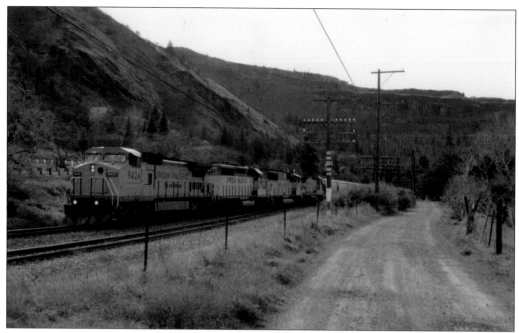

RAINBOW GLASS. Union Pacific No. 9424, with its new windshield glass reflecting a full spectrum of colors, leads three other locomotives moving a long train of covered hoppers eastward at Rowena, Oregon, on April 2, 1997. On the right is a pastoral access road leading to a farmer's orchards. (Photograph by D.C. Jesse Burkhardt.)

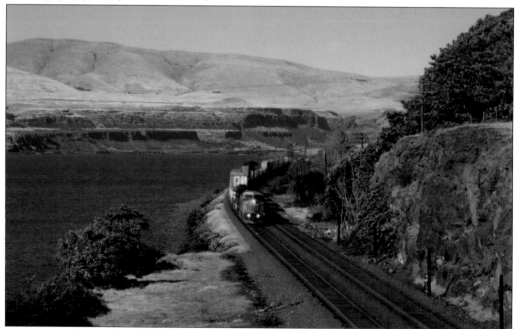

FORMER RIVALS HANDLE THE LOAD. Locomotives from the rosters of Chicago & NorthWestern and Southern Pacific lead a westbound stack train on UP's Portland Subdivision rails in August 1997. These railroads competed with Union Pacific before being merged into the company. The train is just east of The Dalles Dam, which was completed in 1957. (Photograph by D.C. Jesse Burkhardt.)

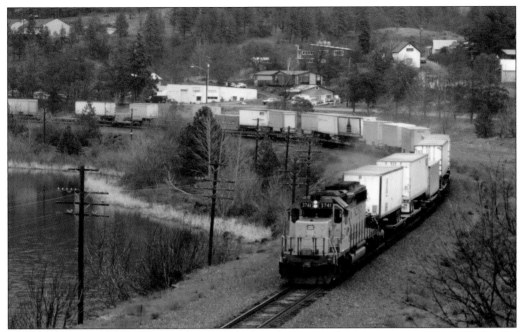

SOLO DUTY. In a relatively rare sight, a Union Pacific intermodal train moves westward behind a single locomotive as it passes through Mosier on March 9, 1995. Multiple units are the norm. The engine, UP SD40-2 No. 3741, is hauling a mix of trailers and containers to Portland. (Photograph by D.C. Jesse Burkhardt.)

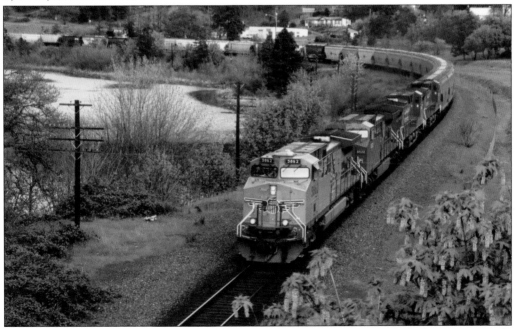

CANADIAN INCURSION. On April 16, 2003, a Union Pacific locomotive—with the carrier's newly unveiled winged-shield logo—rolls westbound through Mosier with a trainload of soda ash. Helping to pull the train, which originated in Wyoming, are three Canadian Pacific engines. Soda ash is a key ingredient in the manufacture of glass. (Photograph by D.C. Jesse Burkhardt.)

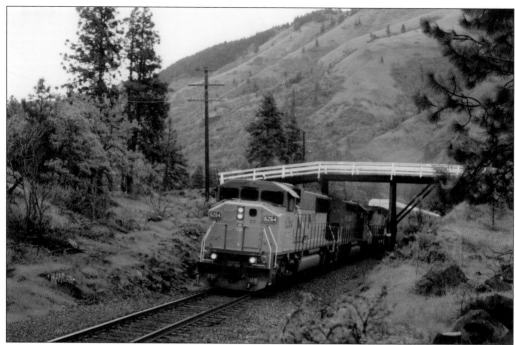

ONE-LANE BRIDGE. Fresh spring growth casts a pale green glow over the surroundings as westbound auto-racks, powered by a mix of Union Pacific and Southern Pacific engines (above), blast under an old one-lane automobile bridge along Union Pacific's Portland Subdivision between Mosier and Rowena on a cloudy day in May 1997. Below, on February 17, 2000, another trainload of automobiles rolls eastward under the same "antique" bridge. Sadly, the charming but outmoded wooden-plank bridge was removed in 2001. (Both photographs by D.C. Jesse Burkhardt.)

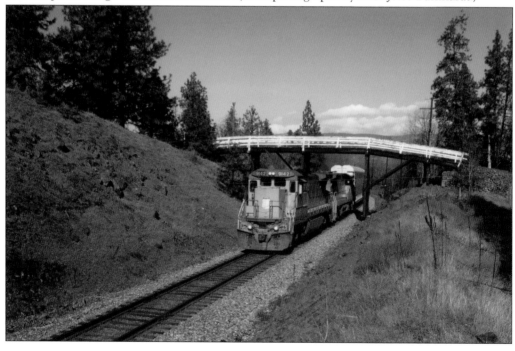

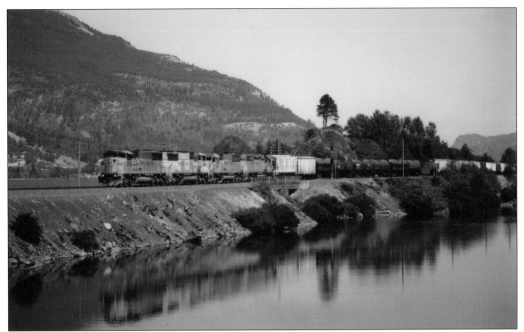

MIRROR IMAGE. Just passing the western end of the siding at Wyeth, Oregon, a long freight train hustles west alongside the Columbia River behind four UP engines on August 10, 1996. At 12,695 feet, the siding at Wyeth is the longest on the entire 185-mile Portland Subdivision. (Photograph by D.C. Jesse Burkhardt.)

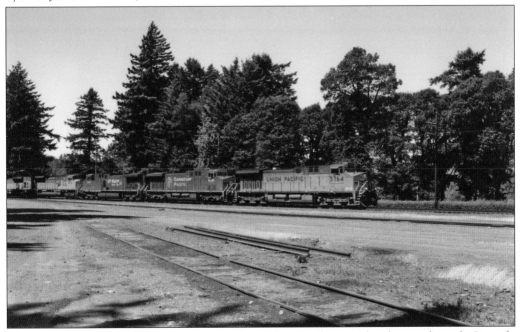

MEETING PLACE. In October 2002, a mixed-manifest freight train heads east through Cascade Locks behind an assortment of locomotives. The siding at Cascade Locks is a frequent meeting place for UP's eastbound and westbound trains passing through the Columbia River Gorge. (Photograph by D.C. Jesse Burkhardt.)

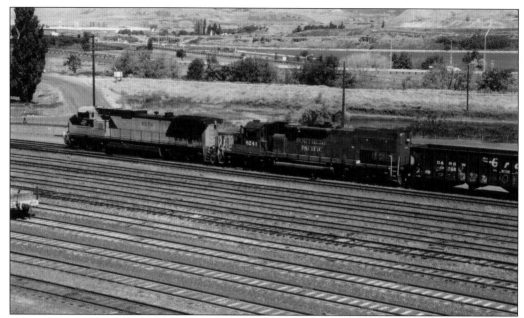

EMPTY TRACKS. On this July day in 1998, the Union Pacific freight yard at The Dalles stands virtually empty except for the presence of a westbound freight that has paused to set out a string of cars. Road locomotives from two of UP's contemporary merger partners, Chicago & NorthWestern (No. 8684) and Southern Pacific (No. 8249), are handling the day's assignment. (Photograph by D.C. Jesse Burkhardt.)

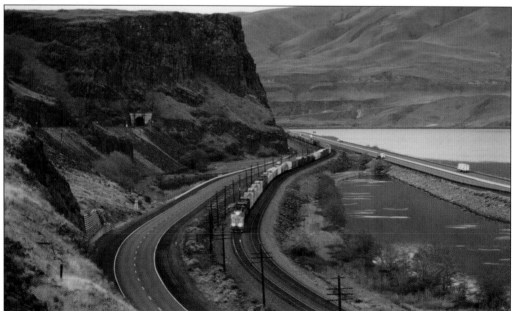

TRANSPORTATION CONCENTRATION. A long freight train on UP's mainline snakes eastward alongside the Columbia River as it approaches Biggs, Oregon, in January 2002. Interstate 84 is to the right of the tracks, and Highway 206, the Celilo-Wasco Highway, is to the left. The tunnel visible halfway up the hillside on the left is part of BNSF's Oregon Trunk Subdivision. (Photograph by D.C. Jesse Burkhardt.)

BEND LOCAL. Until roughly 2005, Union Pacific operated a local between The Dalles and Bend, Oregon. UP used its own Columbia River mainline between The Dalles and O.T. Junction, Oregon, then proceeded via trackage rights over BNSF's Oregon Trunk Subdivision. Union Pacific operated the route—about 160 miles one-way—on a one-day-down, next-day-back schedule, until the closure of lumber mills in Bend resulted in a steep decline in traffic. At right, UP's Bend Local is coming north on March 23, 2002, with 17 freight cars and a caboose. Below, on a return trip from Bend on June 14, 1997, the local passes the southern end of the siding at Moody, Oregon, with five cars and a caboose. The Deschutes River is down the canyon to the right of the train. (Both photographs by D.C. Jesse Burkhardt.)

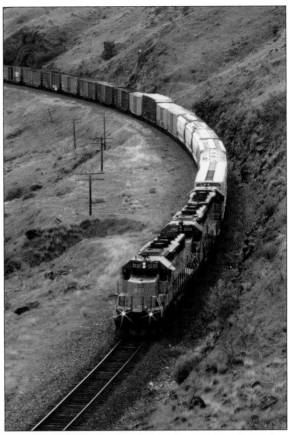

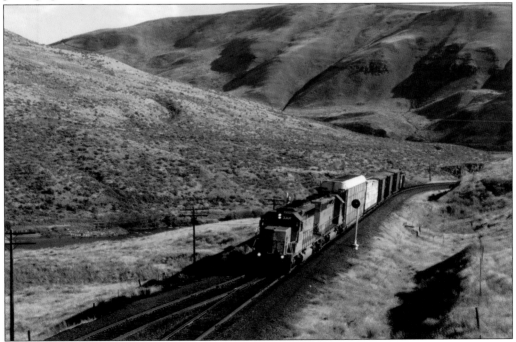

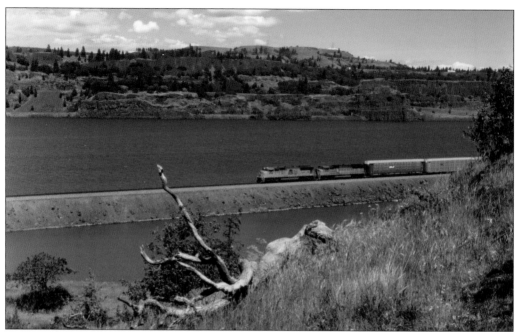

AUTOMOBILES WEST. Running on an earthen fill that separates McClure Lake from the Columbia River, roughly halfway between the tiny communities of Rowena and Mosier, a Union Pacific automobile manifest roars into view on the main track, powering past green hillsides and a weathered, fallen tree as it heads toward Portland on May 15, 2002. UP's new "Building America" slogan and a large American flag are emblazoned on the side of the leading locomotive, UP SD70 No. 4766, which was built in March 2002, just a few weeks before these photographs were taken. (Both photographs by D.C. Jesse Burkhardt.)

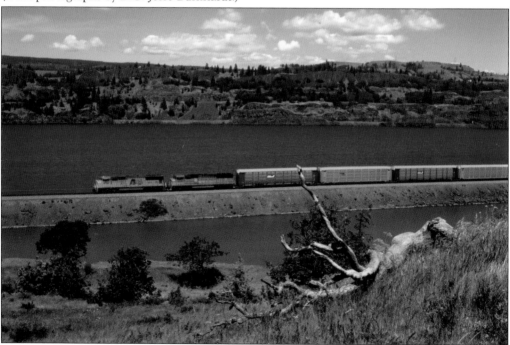

CHANGING SEASONS. Since UP repaints the engines it inherited in various mergers, the appearance of Denver & Rio Grande Western (D&RGW) locomotive No. 5354 (above) in its original colors on April 28, 2004, is a bit of a rarity. As spring flowers bloom on the hillsides, the D&RGW engine is assisting two UP units with an eastbound trash train bound for a landfill south of Arlington, Oregon, on UP's Condon Branch. Below, vegetation shows the effects of a hot, dry summer as a freight consist moves east at the same location on September 22, 2005; on the other side of the river, a BNSF container train is heading west. (Both photographs by D.C. Jesse Burkhardt.)

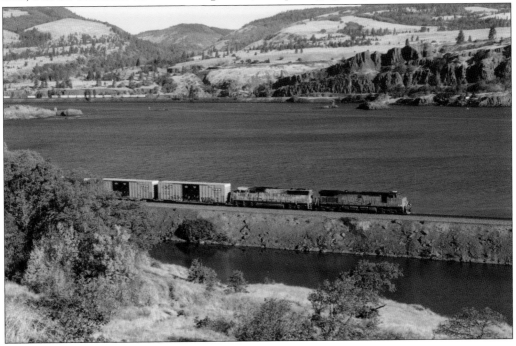

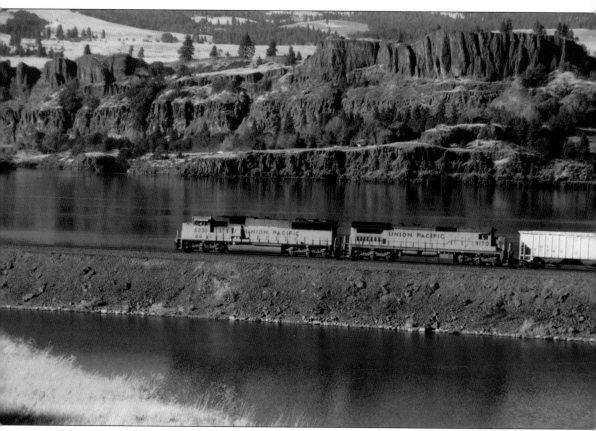

GOLDEN GLOW. A trainload of mixed cargo glides west toward Portland on a calm September day in 1998. The passage of UP's freight train is reflected in the rich, blue water of McClure Lake, which appears in the foreground in this scene. Behind the train, on the Washington side of the Columbia River, the rocky basalt cliffs of Rowena Gap tower over the dramatic landscape. (Photograph by D.C. Jesse Burkhardt.)

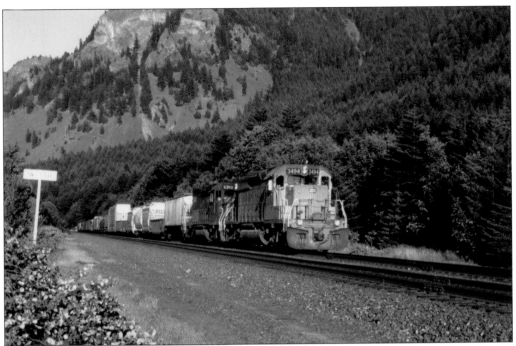

West to the Sun. A mixed-merchandise freight train, powered by Union Pacific SD40-2 No. 3494 and Rio Grande SD40T-2 No. 5359, rumbles toward the setting sun on July 12, 1998. The relatively short train, moving west past a faded station sign on Union Pacific's Portland Subdivision, has taken the siding at Wyeth to let a higher-priority eastbound container train slip past. (Photograph by D.C. Jesse Burkhardt.)

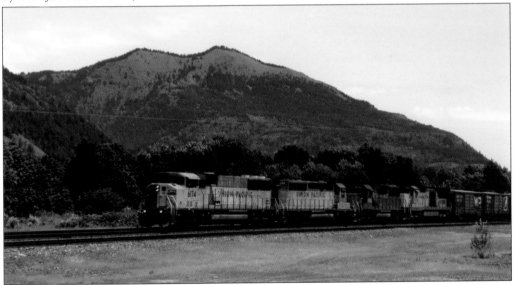

Wyeth. With soft green hills looming in the background across the Columbia River, UP and Cotton Belt locomotives bring a westbound freight past the siding at Wyeth on May 14, 1997. Note the Western Pacific (WP) boxcars behind the engines, including one adorned with the "Feather River Route" billboard logo. UP merged with the WP in 1982, but 15 years later, these boxcars looked almost new. (Photograph by D.C. Jesse Burkhardt.)

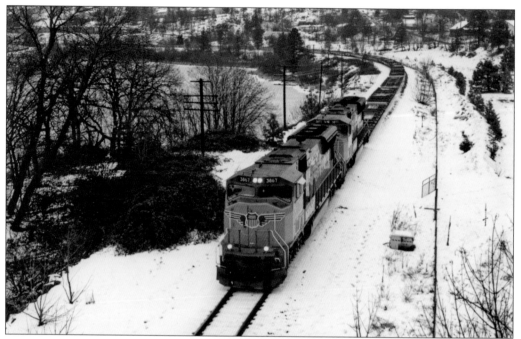

EMPTIES IN THE SNOW. A train of empty flatcars heads west through Mosier on January 29, 2008, after a light snowfall. After reaching the Portland area, the flatcars will be loaded with wind turbine towers, blades, and other equipment, then hauled to a regional wind energy facility in Shutler, Oregon, on Union Pacific's Condon Branch. (Photograph by D.C. Jesse Burkhardt.)

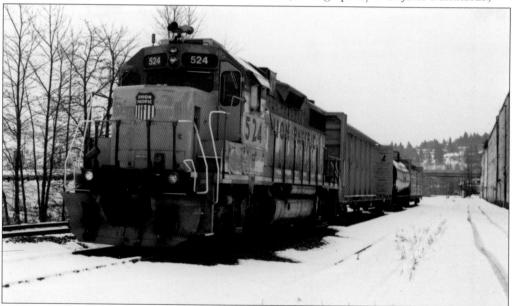

WAREHOUSE DISTRICT. This UP local is tied up on a siding in snowy Hood River on January 29, 2008. The tank car is likely bound for the Hood River Distillers facility in a local industrial park, while the empty centerbeam lumber car will be interchanged with the Mount Hood Railroad, a shortline railroad based in Hood River. At right is the old Union Building, a former fruit warehouse erected in 1905. (Photograph by D.C. Jesse Burkhardt.)

Three

WHERE RAIN AND SUN MEET

GORGE IMAGES

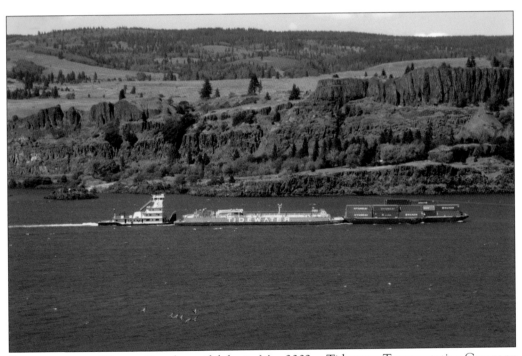

FREIGHT ON THE WATER. On a beautiful day in May 2002, a Tidewater Transportation Company tug pushes two barges, including one loaded with containers, eastward on the Columbia River near Rowena, Oregon. Tidewater, based in Vancouver, Washington, operates over a 465-mile network of waterways, moving goods from the mouth of the Columbia River at Astoria, Oregon, to Lewiston, Idaho, on the Snake River. (Photograph by D.C. Jesse Burkhardt.)

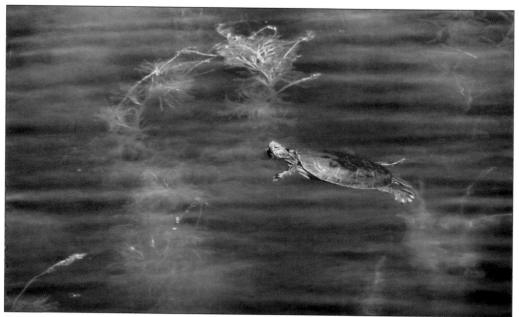

GOOD DAY FOR A SWIM. Turtles are a relatively rare sight around the Columbia River Gorge, but now and then, they can be spotted in the area's lakes and ponds. This colorful Western painted turtle, native to the Northwest, was observed swimming in a pond a few miles west of The Dalles, Oregon, in July 2009. These turtles can grow to 10 inches long. (Photograph by D.C. Jesse Burkhardt.)

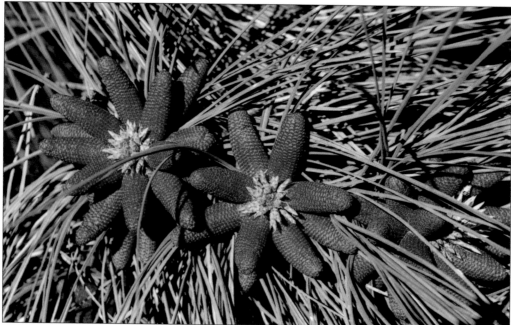

PONDEROSA POLLEN. Ponderosa pine trees, common in the Columbia River Gorge, sprout colorful pollen cones in the spring. Pollen from these pods blows in the wind and pollinates the tree's pine cones. These trees were growing near Bingen, Washington, less than a quarter-mile from the Columbia River. (Photograph by D.C. Jesse Burkhardt.)

SUMMER BREEZE AND WINTER FREEZE.
Many creeks in the Columbia River Gorge either flow fast or completely dry up depending on the season. In spring, rain and snowmelt typically create a torrent of water, and impromptu waterfalls dot the landscape, as exemplified by a May 2011 photograph (right) of Rowland Lake Falls. By late summer, dry conditions are normal, and waterfalls often disappear. However, during the winter, with its rain and freezing cold, these temporary waterfalls sometimes become artistic ice sculptures, as shown below in a photograph taken at the same location in the winter of 2010. (Both photographs by D.C. Jesse Burkhardt.)

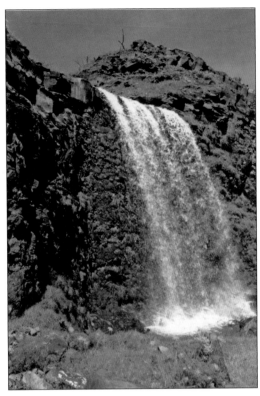

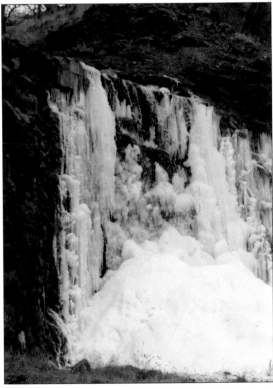

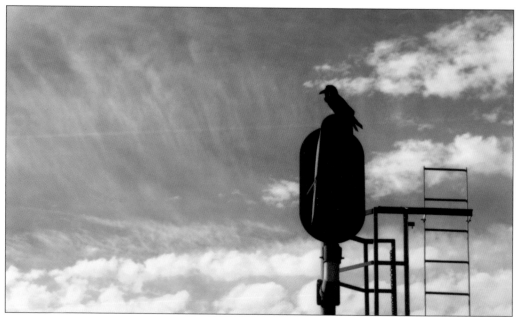

VIEW FROM THE TOWER. A solitary raven perches atop a signal tower at the eastern end of the BNSF siding on the railroad's Columbia River Gorge mainline at Doug's Beach, Washington, on March 28, 2015. (Photograph by D.C. Jesse Burkhardt.)

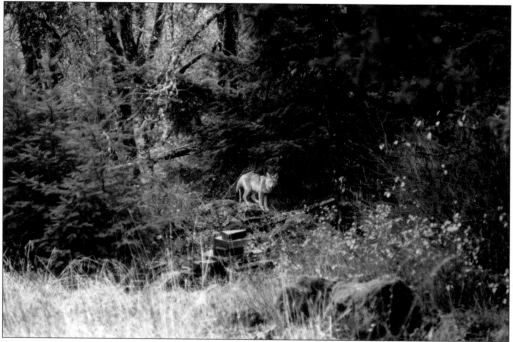

WARY VISITOR. The Columbia River Gorge is home to a variety of wildlife, and it is not unusual for humans and animals to have close encounters. Bears, bobcats, cougars, porcupines, and wild turkeys are among the interesting creatures living in the gorge. In this December 1997 image from western Klickitat County in Washington, a lone coyote eyes the photographer warily as it pauses on its way through the woods. (Photograph by D.C. Jesse Burkhardt.)

THE PUMPKIN PATCH DRAGON. Meadows Mountain View Farms, located in the rolling hills above the White Salmon River in Washington, provided a bounty of fresh seasonal vegetables for many years until the company closed in 2006. The highlight for the business always seemed to be Halloween activities—especially the farm's pumpkin patch, which came complete with a friendly dragon. (Photograph by D.C. Jesse Burkhardt.)

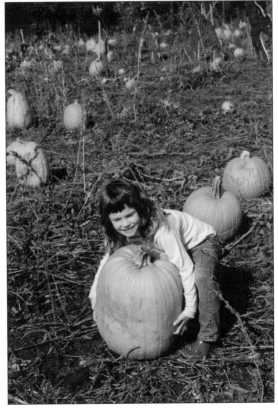

HALLOWEEN DREAMS, 2002. Every autumn, families with youngsters flocked to Meadows Mountain View Farms to visit the company's pumpkin patch, which featured a ride on a hay wagon and furry animals to pet. Choosing the perfect Halloween pumpkin was usually the biggest part of the fun, but kids sometimes let their imaginations get ahead of them, as this girl soon discovered when she attempted to lift a pumpkin almost as big as she is. (Photograph by D.C. Jesse Burkhardt.)

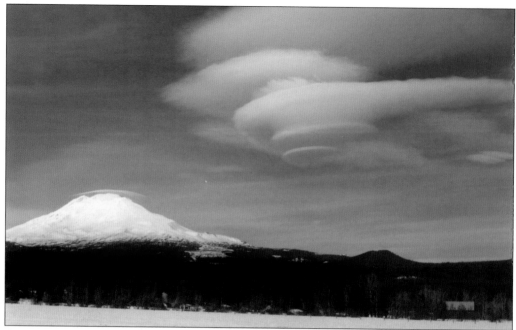

CLOUDS OF MYSTERY. Looking like alien spacecraft, lenticular clouds form in the wind shadow of Mount Adams, a 12,276-foot peak that looms over the landscape north of Trout Lake, Washington. Although it is not located within the boundaries of the Columbia River Gorge National Scenic Area, Mount Adams is one of the scenic focal points of the gorge region. (Photograph by D.C. Jesse Burkhardt.)

THE FIRE OUTSIDE. This vibrant July 1998 sunset, perhaps the result of wildfires in the region, provided a golden-orange treat that lasted for about 15 minutes. This photograph—with no colorizing filters—was taken from a hill between White Salmon and Husum in Washington. (Photograph by D.C. Jesse Burkhardt.)

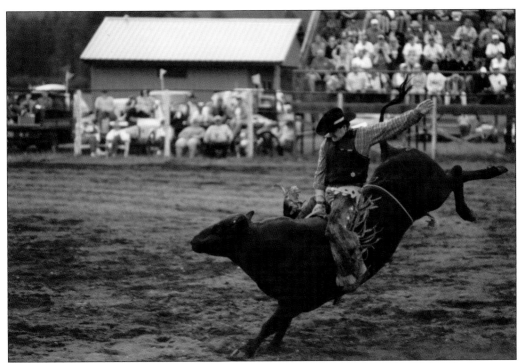

JOY OF BULL RIDING. Dale Jones, of Ridgefield, Washington, enjoyed a brief, bumpy ride before getting propelled off a wild and ornery bull during action at the 66th annual Ketchum Kalf Rodeo in Glenwood, Washington, in June 2000. Glenwood is about 35 miles north of the Columbia River and outside the National Scenic Area, but the popular rodeo festivities attract thousands of people every year. In addition to bull riding, other events include steer wrestling, bareback bronc riding, barrel racing, and team roping. The Glenwood rodeo, which is held on Father's Day weekend, got its start in 1934. (Both photographs by D.C. Jesse Burkhardt.)

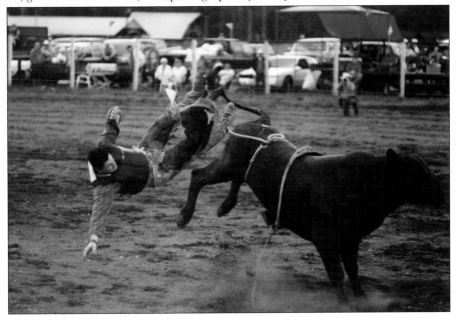

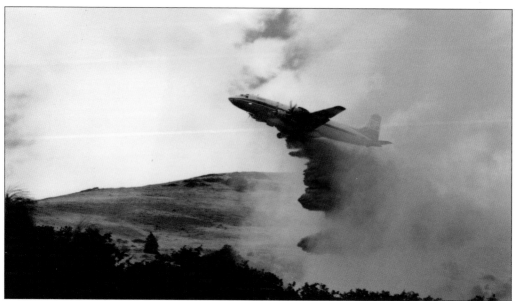

KNOCKOUT BLOW. Wildfires are a natural part of life in the Columbia River Gorge, and effective firefighting operations are essential to the protection of lives and property. In the autumn of 2001, a wildfire near Lyle, Washington, required the biggest weapons in the firefighting arsenal: air tankers dropping retardant to halt the spread of flames. (Photograph by D.C. Jesse Burkhardt.)

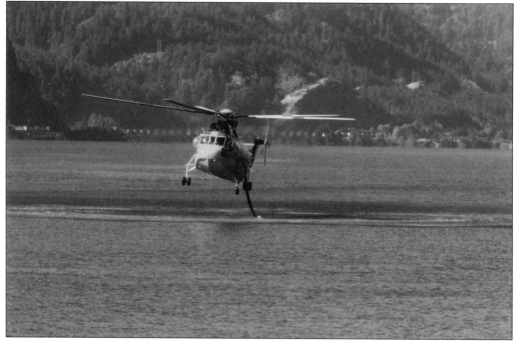

DOWN ON THE DECK. On September 20, 2007, a dangerous wildfire flared up near Underwood, Washington. Hot temperatures and high winds pushed the blaze, and firefighting helicopters from the Washington Department of Natural Resources were called in to assist. The innovative helicopters dipped hoses into the Columbia River, sucking up water to drop on the fire. Roughly 150 acres burned, and six homes were destroyed. (Photograph by D.C. Jesse Burkhardt.)

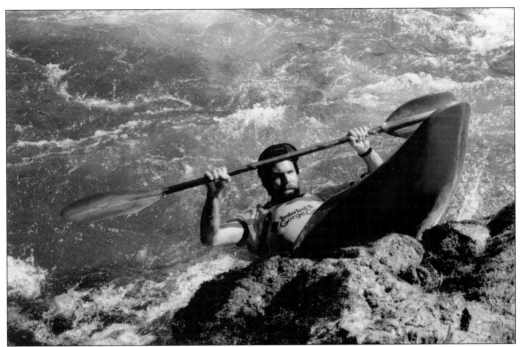

ROCK HANGING. Scott McGuire, of Camino, California, propels his kayak onto rocks along the White Salmon River during freestyle kayaking events held near Husum Falls at Husum, Washington, in July 1998. McGuire was one of dozens of participants in that summer's Timberland Gorge Games, held at locations around the Columbia River Gorge. The games were billed by organizers as a "week-long celebration focusing on real people doing real sports in a real place." (Photograph by D.C. Jesse Burkhardt.)

GORGEOUS BREWS. A postcard from the Full Sail Brewing Company in Hood River, Oregon, uses windsurfing imagery to highlight its variety of popular beers. The brewery, perched on a hillside directly overlooking the Columbia River, promotes its location in the gorge as the "home of great scenery, great sailing, and great beer!" (Courtesy of the Full Sail Brewing Company.)

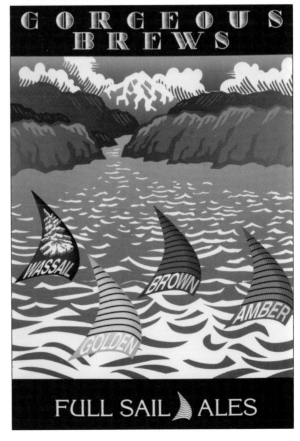

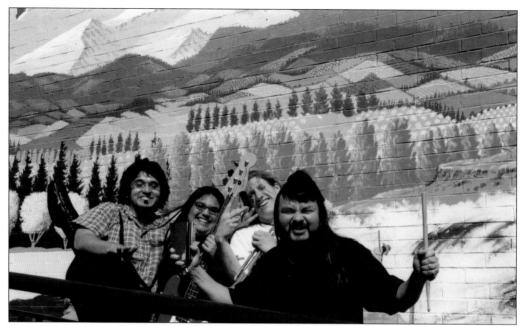

BAND ON THE RISE. Musicians from the gorge-based reggae band Luna Rise share a moment of levity in front of a colorful mural in downtown Hood River, Oregon, after completing a performance in April 2001. The group was in Hood River as part of the city's Columbia Gorge Earth Day celebration. Shown here are, from left to right, Josh Benavides, Debbie Benavides, Scott Head, and Jose Maya. (Photograph by D.C. Jesse Burkhardt.)

SWEET MUSIC. Gorge musician Richard Tillinghast shows off his new album, *Sweet By and By*, at Rowland Lake, Washington, in March 2008. The album celebrates the Columbia River Gorge with music described as "unique American folk-pop." Tillinghast and his OneHum Band commemorated the album's release with a performance at the Solstice Café in Bingen, Washington, on April 26, 2008. (Photograph by D.C. Jesse Burkhardt.)

NIGHTMARE. Figures from another dimension loom menacingly in the darkness during the 2007 Halloween "Monster Mash" event at Henkle Middle School in White Salmon, Washington. Students and staff at White Salmon's Columbia High School organize the event each year, with proceeds going to support students at the middle school. (Photograph by D.C. Jesse Burkhardt.)

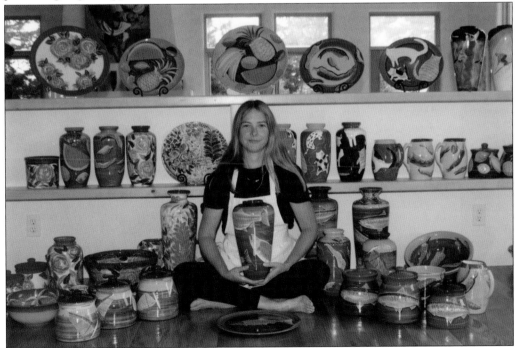

POTTER'S ART. Julie Ueland strikes a calm and peaceful pose as she relaxes while surrounded by her beautiful ceramic creations at her Backsplash studio in White Salmon. Much of Ueland's work features salmon, a symbol of the Columbia River's history. (Photograph by Elaine Bakke.)

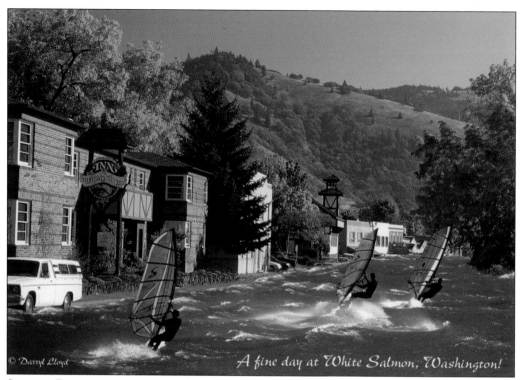

SURFING DOWNTOWN. Jewett Boulevard in White Salmon, Washington, goes right through the city's downtown business district. Here, it has been transformed into a flowing river filled with happy windsurfers thanks to the clever vision and Photoshop talents of gorge photographer Darryl Lloyd. A resident of Hood River, Oregon, Lloyd created this popular postcard in 1999. (Photo-illustration by Darryl Lloyd.)

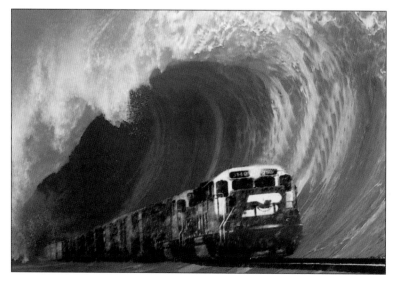

PIPELINE. An eastbound Burlington Northern freight at Bingen, Washington, looks as if it is about to be engulfed by a huge wave—another display of Photoshop wizardry—in this scene. The postcard celebrates the flood of trains that race through the Columbia River Gorge every day. (Photo-illustration by Bob Dobyne.)

Four

ROLLING SCENERY

AMTRAK IN THE GORGE

ROMANCE OF THE RAILS. In 2006, Amtrak produced a series of dramatic prints, created by artist Michael Schwab, and presented postcard versions of the prints as mementos for its first-class passengers. Included in the gift packet was a map of Amtrak's nationwide system and prose that evoked romantic images of rail travel on the *Empire Builder* and other Amtrak trains: "On these paths ride the great iron horses carrying passengers to new adventures, old loves, and endless possibilities." (Courtesy of Amtrak.)

EMPIRE BUILDER

7/27			◀ Train Number ▶			8/28
Daily			◀ Normal Days of Operation ▶			Daily
ℝ 🍴 ✕ 🍷 🚃			◀ On Board Service ▶			ℝ 🍴 ✕ 🍷 🚃
Read Down	Mile	▼		Symbol	▲	Read Up
2 15P	0	Dp	Chicago, IL–Union Station (CT)	●&♿	Ar	3 55P
R2 39P	17		Glenview, IL (METRA/Milw. Line)	●&♿		D3 12P
R3 55P	85		Milwaukee, WI	●&♿		D2 07P
5 05P	150		Columbus, WI (Madison)	●♿		12 57P
5 34P	178		Portage, WI	O♿		12 27P
5 52P	195		Wisconsin Dells, WI	O♿		12 08P
6 30P	240		Tomah, WI	O♿		11 26A
7 14P	281		La Crosse, WI	●♿		10 47A
7 50P	308		Winona, MN 🚌 Rochester—see back	●♿		10 11A
8 52P	371		Red Wing, MN	O♿		8 54A
10 03P	418	Ar	St. Paul-Minneapolis, MN 🚌 Duluth—see back	●♿♿	Dp	8 00A
10 10P		Dp			Ar	7 52A
12 40A	486		St. Cloud, MN	O♿♿		5 14A
1 42A	552		Staples, MN	O		4 09A
2 38A	614		Detroit Lakes, MN	O		3 10A
3 35A	662		Fargo, ND (Moorhead, MN)	●&		2 13A
4 52A	737		Grand Forks, ND	●&		12 57A
6 13A	822		Devils Lake, ND	O♿		11 32P
7 07A	879		Rugby, ND	●♿		10 38P
8 34A	940	Ar	Minot, ND	●♿	Dp	9 42P
9 06A		Dp			Ar	9 22P
9 57A	994		Stanley, ND	O♿		8 11P
11 07A	1061		Williston, ND (CT)	●♿		7 09P
11 41A	1168		Wolf Point, MT (MT)	●♿		4 33P
12 26P	1217		Glasgow, MT	O&		3 47P
1 25P	1283		Malta, MT	O♿		2 52P
2 39P	1370	Ar	Havre, MT	●♿	Dp	1 32P
3 04P		Dp			Ar	1 12P
5 22P	1475		Shelby, MT	●♿		11 43A
5 51P	1499		Cut Bank, MT	O♿		10 45A
40 6 23P	1532		Browning, MT 40	O		40 10 10A
40 6 45P	1547		East Glacier Park, MT 40	●♿		40 9 54A
7 41P	1576		Essex, MT–Izaak Walton Inn	O		8 55A
8 23P	1603		West Glacier, MT (Apgar)	O		8 16A
8 56P	1626	Ar	Whitefish, MT	●&	Dp	7 46A
9 16P		Dp			Ar	7 26A
10 59P	1728		Libby, MT (MT)	O♿		5 26A
11 49P	1813		Sandpoint, ID (PT)	O♿		2 35A
1 40A	1879	Ar	Spokane, WA (PT) (Coeur d'Alene, ID)	●&♿	Dp	1 30A

27			Through cars Chicago–Portland			28
2 45A	1879	Dp	Spokane, WA (PT)	●&♿	Ar	12 13A
5 35A	2025		Pasco, WA (Kennewick, Richland)	●&♿		8 57P
7 30A	2150		Wishram, WA (The Dalles)	O♿		6 55P
8 04A	2180		Bingen-White Salmon, WA	O♿		6 21P
9 18A	2245		Vancouver, WA	●&♿		5 07P
39 10 10A	2255	Ar	Portland, OR (PT)	●&♿	Dp	39 4 45P

7			Through cars Chicago–Seattle			8
2 15A	1879	Dp	Spokane, WA (PT)	●&♿	Ar	12 45A
4 22A	1998		Ephrata, WA	O&		9 42P
5 35A	2050		Wenatchee, WA 🚌 Omak—see back	O&		8 42P
6 08A	2072		Leavenworth, WA	O&		8 00P
8 38A	2171		Everett, WA	●♿♿		5 39P
9 10A	2188		Edmonds, WA	●&♿		5 12P
10 25A	2205	Ar	Seattle, WA (Victoria, BC) (PT) 🚌 Vancouver, BC—see back	●♿♿	Dp	4 40P

Possible Empire Builder Adjustment

The Empire Builder schedule is subject to change while the BNSF Railway carries out track infrastructure projects to increase capacity in North Dakota and Montana for both passenger and freight train traffic. As these projects are completed, Empire Builder schedules are likely to be adjusted. Please consult Amtrak.com or call Amtrak.

RIDE ON THE EMPIRE BUILDER. Amtrak's summer/fall 2014 schedule lists stations served by the daily Empire Builder, which operates between Chicago and the West Coast cities of Portland and Seattle (as two separate sections). An eastbound train leaves Seattle on a northern route via Wenatchee, Washington, while a different section of the same train leaves Portland at roughly the same time and travels via the Columbia River Gorge. The two trains meet and combine in Spokane, Washington, before continuing to Chicago. Coming west, the process is reversed: the train separates in Spokane to complete the run. (Courtesy of Amtrak.)

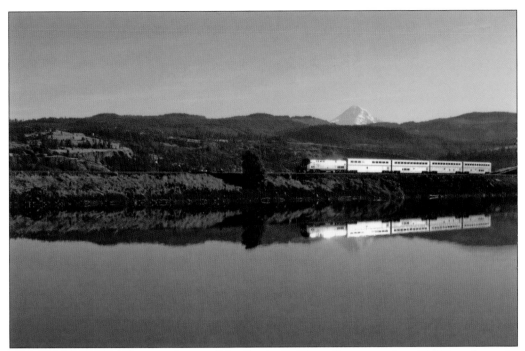

SCENIC ROUTE THROUGH THE GORGE. The *Empire Builder* rolls eastward on BNSF tracks on its two-day, 2,255-mile run from Portland to Chicago. The passenger train was named for the legendary James J. Hill, onetime owner of the Great Northern Railway, among other holdings. The train has just two station stops in the Columbia River Gorge National Scenic Area, both in Washington: Bingen–White Salmon and Wishram. As it crosses the Rowland Lake causeway (below), this four-car train creates a nearly perfect mirror image on the lake's still water. To further highlight the scenic attractions of this Amtrak route, Oregon's snow-capped Mount Hood is clearly visible in the distance in the above image. (Both photographs by D.C. Jesse Burkhardt.)

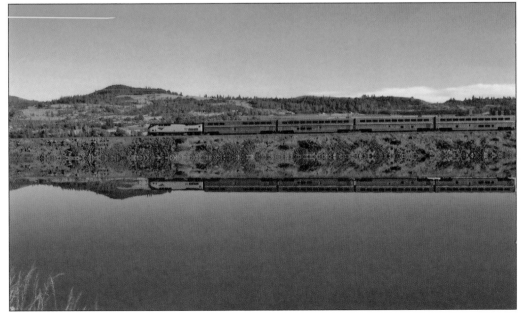

AMTRAK®
Pioneer

Fall/Winter 1996/97 Effective November 10
Chicago...Denver...
Boise...Portland...Seattle

25			◄ Train Number ►		26	
Dp Chicago SuTuTh			◄ Days of Operation ►		Ar Chicago WeFrMo	
ReadDown	Mile	▼		Symbol	▲	Read Up
🚌 Amtrak Thruway Bus Connection—Madison, WI/Chicago, IL—Schedule Below						
3 05P	0	Dp	Chicago, IL–Union Sta. ● (CT)	🚭♿	Ar	4 15P
[19] 3 41P	28		Naperville, IL (METRA/BN Line)	♿		[19] 2 51P
4 51P	104		Princeton, IL	●		1 39P
5 53P	162		Galesburg, IL–S. Seminary St.	♿		12 47P
6 44P	205		Burlington, IA	●♿		11 53A
7 19P	233		Mt. Pleasant, IA	🚭♿		11 19A
8 05P	280		Ottumwa, IA	🚭♿		10 33A
9 23P	360		Osceola, IA (Des Moines)	●		9 11A
9 58P	393	▼	Creston, IA	●♿		8 34A
🚌 Amtrak Thruway Bus Connection—Kansas City, MO/Omaha, NE—Schedule Below						
12 12A	501	Ar	Omaha, NE	🚭♿	Dp	6 44A
12 37A		Dp			Ar	6 19A
1 41A	555	Ar	Lincoln, NE	🚭♿	Dp	4 54A
1 51A		Dp			Ar	4 44A
3 28A	652		Hastings, NE (Grand Island)	🚭♿		3 11A
4 16A	706		Holdrege, NE	●♿		2 21A
5 26A	784	▼	McCook, NE (CT)	●♿		1 13A
6 48A	960		Fort Morgan, CO (Sterling) (MT)	●♿		9 48P
8 45A	1037	Ar	Denver, CO (Col. Sprgs. 🚌) ●	🚭♿	Dp	8 30P
			Days of Operation to/from Seattle			
10 10A	1037	Dp	Denver, CO (Col. Sprgs. 🚌) ●	🚭♿	Ar	6 05P
11 15A	1090		Greeley, CO	●		3 45P
12 15P	1141		West Cheyenne-Borie, WY	●		2 45P
🚌 Amtrak Thruway Bus Connection—West Cheyenne-Borie, WY/Cheyenne, WY—Schedule Below						
1 19P	1187		Laramie, WY	🚭♿		1 50P
3 09P	1304		Rawlins, WY	●♿		11 59A
4 49P	1424		Rock Springs, WY	●♿		10 19A
5 14P	1437		Green River, WY	●♿		9 59A
6 58P	1539	▼	Evanston, WY	●♿		7 49A
9 31P	1614	Ar	Ogden, UT	🚭♿	Dp	6 38A
9 51P		Dp			Ar	6 18A
🚌 Amtrak Thruway Bus Connection—Ogden/Salt Lake City—Schedule Below						
12 24A	1750		Pocatello, ID	●♿		3 16A
2 05A	1857		Shoshone, ID (Twin Falls)	●♿		1 36A
4 24A	1984		Boise, ID	🚭♿		11 26P
5 23A	2003		Nampa, ID	●♿		10 46P
5 58A	2043		Ontario, OR (MT)	●♿		9 58P
6 53A	2133	▼	Baker City, OR (PT)	●♿		6 58P
8 01A	2185		La Grande, OR	●♿		5 58P
10 33A	2259	Ar	Pendleton, OR	●♿	Dp	3 40P
		Dp			Ar	3 33P
11 23A	2290		Hinkle-Hermiston, OR	●♿		2 42P
12 40P	2390		The Dalles, OR	●♿		1 22P
1 13P	2412		Hood River, OR	●♿		12 55P
2 30P	2475	Ar	Portland, OR ●	🚭♿	Dp	11 40A
3 05P		Dp			Ar	11 25A
3 27P	2485		Vancouver, WA	🚭♿		10 56A
4 07P	2524		Kelso-Longview, WA	●♿		10 15A
4 51P	2567		Centralia, WA	🚭♿		9 30A
5 12P	2589	▼	Olympia-Lacey, WA	●♿		9 08A
5 58P	2622		Tacoma, WA	🚭♿		8 26A
7 00P	2662	Ar	Seattle, WA ● (PT)	🚭♿	Dp	7 30A

Connecting Services

🚌 Amtrak Thruway Bus Connection—Madison, WI/Chicago, IL							
10 00A	0	Dp	Madison, WI–Memorial Union	●	Ar	11 30P	
11 00A	35		Janesville, WI	●	▲	10 20P	
11 25A	48		Beloit, WI	●		9 55P	
11 50A	65		Rockford, IL	●	Ar	9 30P	
1 55P	140	Ar	Chicago, IL ● (CT)		Dp	8 00P	
🚌 Amtrak Thruway Bus Connection—Kansas City, MO/Omaha, NE							
6 30P	0	Dp	Kansas City, MO ●		Ar	12 00N	
8 00P	54		St. Joseph, MO	●		11 00A	
10 30P	198	Ar	Omaha, NE (CT)		Dp	8 00A	
🚌 Amtrak Thruway Bus Connection—West Cheyenne-Borie, WY/Cheyenne, WY							
11 45A	0	Dp	Cheyenne, WY ● (MT)	●	Ar	3 05P	
12 00N	10	Ar	West Cheyenne-Borie, WY	●	Dp	2 55P	
12 20P	0	Dp	West Cheyenne-Borie, WY	●	Ar	2 30P	
12 30P	10	Ar	Cheyenne, WY ●	●	Dp	2 15P	
🚌 Amtrak Thruway Bus Connection—Ogden, UT/Salt Lake City, UT							
8 10P	0	Dp	Salt Lake City, UT ● (MT)	🚭	Ar	7 00A	
8 55P	36	Ar	Ogden, UT	🚭	Dp	6 20A	
9 40P	0	Dp	Ogden, UT	🚭	Ar	5 50A	
10 25P	36	Ar	Salt Lake City, UT ●	🚭	Dp	5 05A	

FINAL TIMETABLE. This 1996/1997 schedule for the Amtrak *Pioneer* was its last one, as the Seattle-to-Chicago train was about to be axed. Before the train's demise, a sad notice posted at affected stations read, in part: "Despite great interest and substantial concern expressed by many states, no formal commitments have been made to fund . . . the route of the *Pioneer*. Therefore, effective with the Amtrak timetable change on May 11, 1997, the *Pioneer* will be discontinued." The cutback ended Amtrak service to several Oregon cities, including Hood River and The Dalles in the gorge. The 2,662-mile trip between Chicago and Seattle took roughly two days. (Courtesy of Amtrak.)

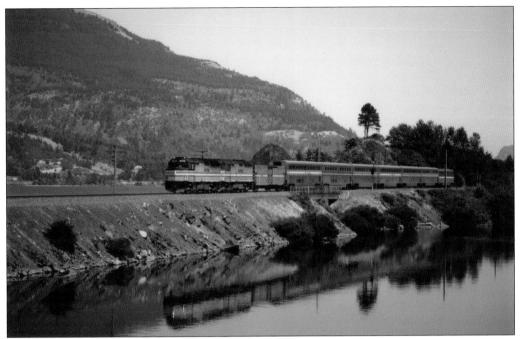

ENDANGERED TRAIN. On August 10, 1996, Amtrak's *Pioneer* rushes westbound alongside the Columbia River at Wyeth, Oregon. The train, which ran between Seattle and Chicago via Portland and Denver, was terminated because ridership was not meeting expectations. (Photograph by D.C. Jesse Burkhardt.)

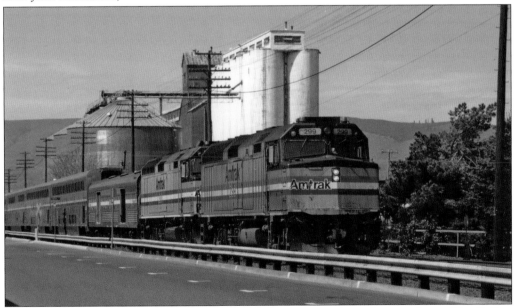

PIONEER STATION. The *Pioneer*, which ran three times per week, is about to depart The Dalles, Oregon, on April 12, 1997. This eastbound was one of the Seattle-to-Chicago train's final appearances in The Dalles, as the last run of the *Pioneer* was on May 10, 1997. Unfortunately, more than passenger train operations were about to be lost: the wonderful, historic grain elevators visible behind the train were demolished in 1998. (Photograph by D.C. Jesse Burkhardt.)

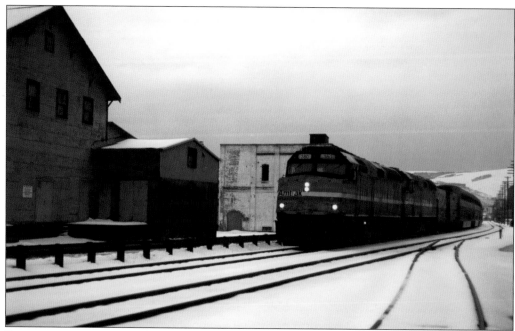

RIDING INTO A NEW YEAR. On January 1, 1997, Amtrak's *Pioneer* cuts eastward through the snow as it passes the old warehouse district at The Dalles, Oregon, on its way to Chicago. The passenger train ran on Union Pacific's Portland Subdivision for the portion of its route through the Columbia River Gorge. (Photograph by D.C. Jesse Burkhardt.)

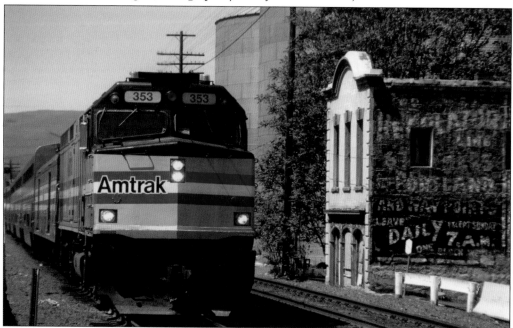

CHANGING LANDSCAPES. On May 7, 1997, an eastbound train pulls into The Dalles, passing an old, fading mural advertising steamship service to Portland. This was just three days before Amtrak dropped the *Pioneer* from its schedule. The structure on which the billboard was painted was erected in 1863 and is the oldest building in The Dalles. (Photograph by D.C. Jesse Burkhardt.)

Welcome to Bingen. A reflective sign attached to a rustic, friendly wooden display greets motorists on State Route 14 just east of Bingen, Washington, in 2015. The signs welcome visitors to the community and let travelers know Amtrak proudly serves the small gorge city, which is situated along the Columbia River in the center of the Columbia River Gorge National Scenic Area. (Photograph by D.C. Jesse Burkhardt.)

Silver Sunset. The setting sun illuminates the sides of Amtrak "Superliner" cars on the day's eastbound *Empire Builder* as it pauses at the Bingen depot in April 1997. The boxcar at the end of the train was used to haul express-freight shipments. (Photograph by D.C. Jesse Burkhardt.)

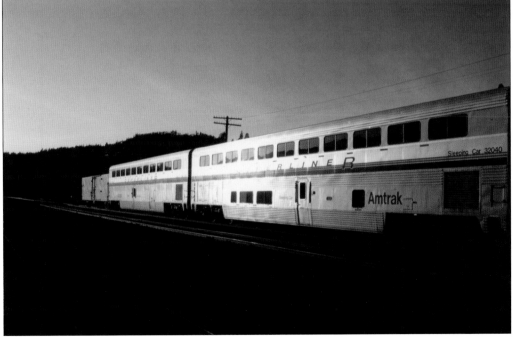

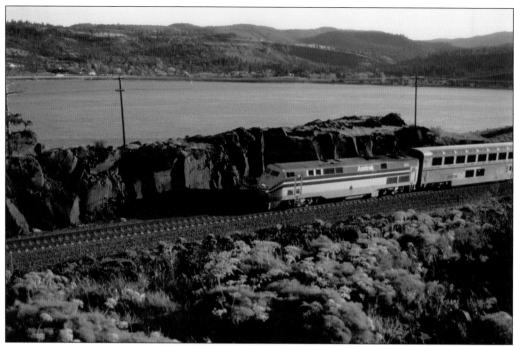

SEASONS OF THE RIVER. Amtrak's *Empire Builder* is a few miles west of Lyle, Washington, as the Chicago-bound train heads eastward in these photographs, which offer a view from the same vantage point in two different seasons. In the above image, on April 16, 1999, Amtrak No. 56 shepherds an eastbounder alongside the Columbia River as desert parsley plants soak up the sun. The vibrant flowers are in full bloom for only a few weeks in early spring, and at that time of year, the sun often sets before the eastbound *Empire Builder* reaches this location. Below, on August 8, 1999, Amtrak No. 322 powers the train through a landscape that is turning brown as the summer sun bakes the region. (Both photographs by D.C. Jesse Burkhardt.)

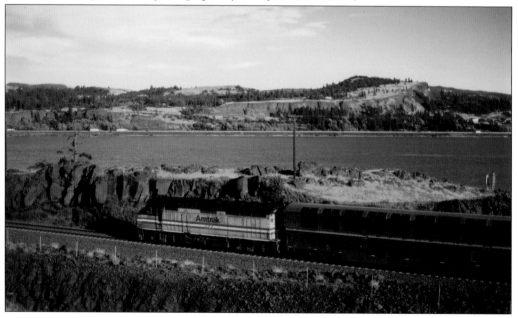

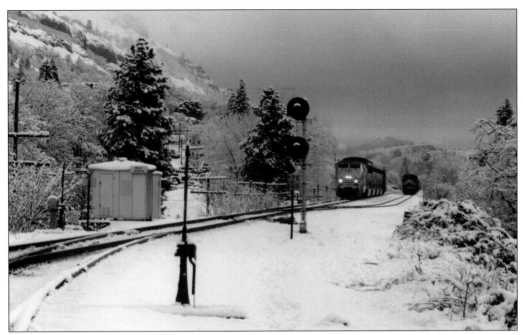

WAITING FOR THE *EMPIRE BUILDER*. After a December 1997 snowfall, Amtrak's daily *Empire Builder* hurtles westward through a cold Columbia River Gorge morning. It is passing a long freight train idling on BNSF's 11,115-foot siding at Bingen, Washington. (Photograph by D.C. Jesse Burkhardt.)

ICY ARRIVAL. With its red marker lights glowing, Amtrak's westbound *Empire Builder* pauses to detrain passengers at the diminutive passenger station in Bingen on a snowy day in December 2005. After leaving Bingen, this train, which originated in Chicago two days earlier, has just two stops remaining before completing its cross-country run: Vancouver, Washington; and Portland, Oregon. (Photograph by D.C. Jesse Burkhardt.)

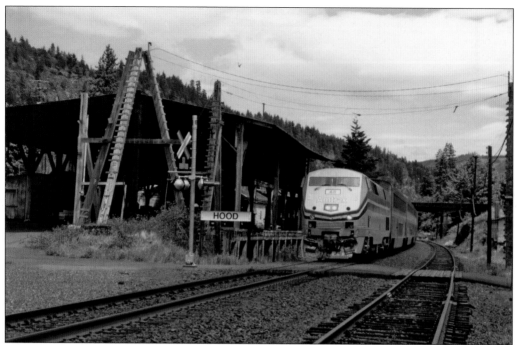

GHOST TOWN. Amtrak's *Empire Builder* pounds west through the deserted station called Hood, Washington, on Independence Day in 1998. The train, running fast on BNSF's Fallbridge Subdivision, is passing the abandoned Broughton Lumber Company complex, which, for many years, shipped finished lumber by rail. The Broughton Lumber mill opened in 1923 and operated until 1986. (Photograph by D.C. Jesse Burkhardt.)

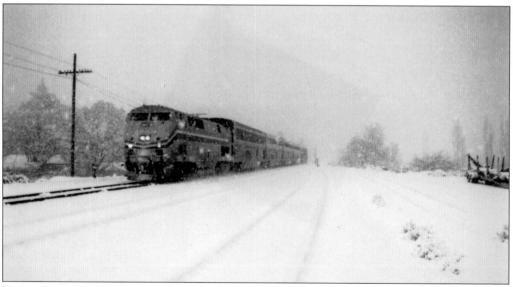

THREE DAYS TO CHRISTMAS. On December 22, 2000, with a train full of holiday passengers, the *Empire Builder* bulls through a blinding snowstorm at Bingen behind a solo P42-9BWH, the model General Electric developed in the early 1990s to take the place of Amtrak's once-common 1970s-era F40PHs. The red and blue striping on the locomotive provides a colorful contrast with the blowing snow. (Photograph by D.C. Jesse Burkhardt.)

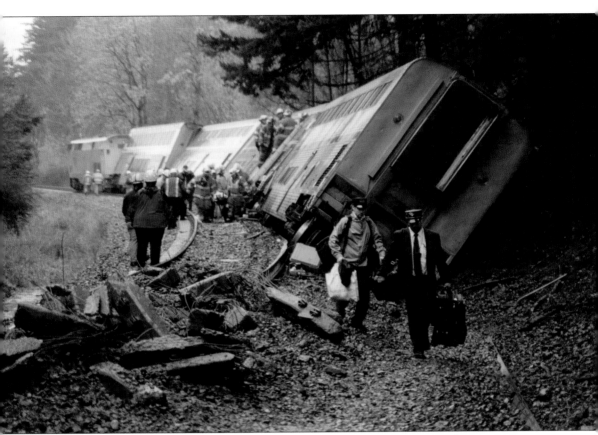

BAD END TO THE JOURNEY. At 9:30 a.m. on April 3, 2005—just 20 minutes after a station stop at Bingen, Washington—all four cars of the westbound *Empire Builder* derailed on a curve and slammed into an embankment at Home Valley, Washington. The train was reportedly moving at 60 miles per hour, a normal speed for this stretch of track, when the mishap occurred. In this photograph, taken after emergency personnel responded to the scene, members of the train's crew walk along torn-up tracks while rescuers work to free a passenger trapped in one of the damaged coaches. None of the 115 people on board were critically hurt. (Photograph by D.C. Jesse Burkhardt.)

Compliments of Amtrak's First Class Service ➤ **Amtrak**

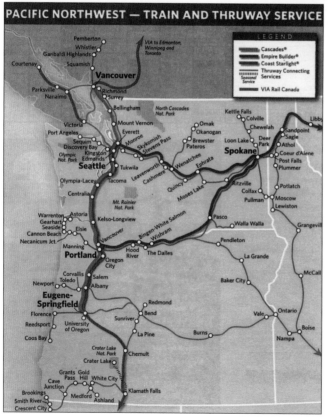

PACIFIC NORTHWEST — TRAIN AND THRUWAY SERVICE

LEGEND
Cascades®
Empire Builder®
Coast Starlight®
Thruway Connecting Services
Seasonal Service
VIA Rail Canada

"**FIRST CLASS SERVICE.**" This promotional postcard issued by Amtrak highlights the Columbia River Gorge and urges travelers to discover the joys of train travel. "Amtrak's *Empire Builder* explores the panoramic Columbia River Gorge," reads the text on the back. "Travel in comfort to more than 475 destinations across the country. And enjoy an eye-level view of America's beauty. Only on Amtrak!" (Collection of D.C. Jesse Burkhardt.)

NORTHWEST TRAINS. Amtrak provides three separate routes for passenger trains in the Pacific Northwest, as well as connecting bus service that reaches many more cities. This November 2011 color-coded map of Oregon and Washington shows where the *Empire Builder*, the *Coast Starlight*, and the *Cascades* trains operate. (Courtesy of Amtrak.)

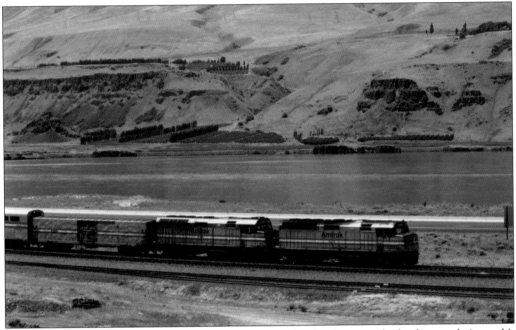

EASTBOUND AT BIGGS. In June 1996, with the calm Columbia River in the background, Amtrak's eastbound *Pioneer* rolls through Biggs, Oregon, behind a pair of aging F40PH locomotives (No. 396 and No. 343). Less than a year after this photograph was taken, the *Pioneer* train was no longer running. (Photograph by D.C. Jesse Burkhardt.)

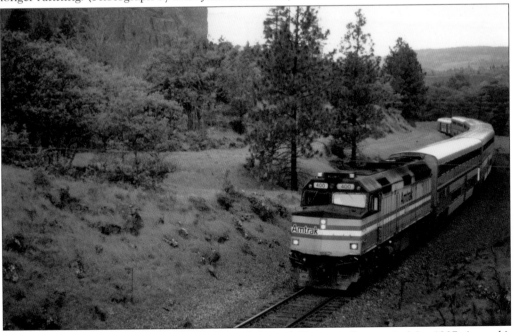

AMTRAK AT SEVENMILE HILL. Rolling eastward through Rowena, Oregon, in May 1997, Amtrak's *Pioneer* cuts through a rock-strewn landscape as it nears its next station stop at The Dalles, Oregon, another eight miles down the tracks. The dramatic rock cliff wall to the left of the train is known as Sevenmile Hill. (Photograph by D.C. Jesse Burkhardt.)

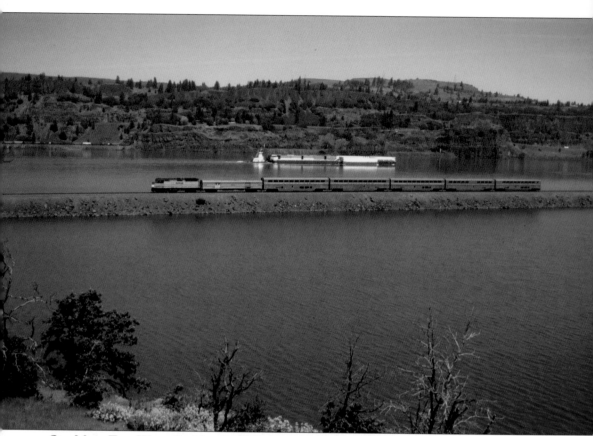

ONE MORE TIME WEST. On May 10, 1997, Amtrak's *Pioneer* makes its final westbound run through the Columbia River Gorge with five passenger cars and a baggage car. The train is rolling on Union Pacific tracks near Rowena, Oregon, on its way to Portland and then to Seattle. In the background, on the northern bank of the river, a BNSF freight heads west on rails that host the *Empire Builder*, while a tug on the river pushes goods eastward. To compensate for the loss of the thrice-weekly *Pioneer*, Amtrak upgraded the *Empire Builder*, which had been operating four days per week, to daily service. (Photograph by D.C. Jesse Burkhardt.)

Five

ORCHARDS AND TIMBER
MOUNT HOOD RAILROAD

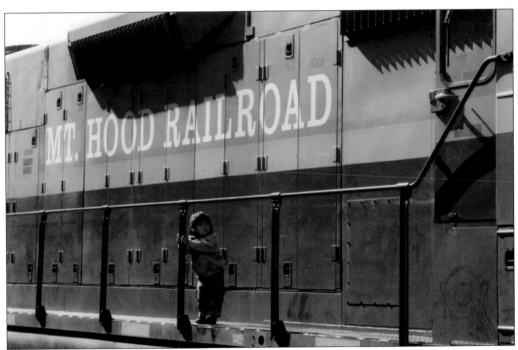

KID-FRIENDLY. During a layover for one of the Mount Hood Railroad's excursion trains at Parkdale, Oregon, in September 2010, a vacationing youngster gets a close look at one of the Oregon shortline's brightly painted locomotives. The Mount Hood operates seasonal tourist excursions on its 21-mile route between Hood River and Parkdale. (Photograph by D.C. Jesse Burkhardt.)

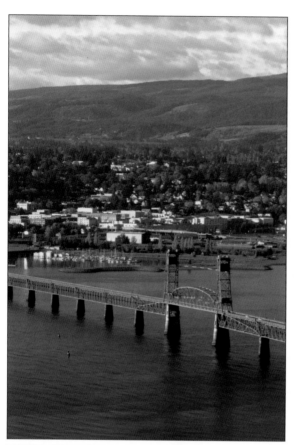

BRIDGE WITH A VIEW. This view from the bluffs around Bingen, Washington, shows the city of Hood River, Oregon—the home of the Mount Hood Railroad. Also visible is the Hood River Toll Bridge, which spans the Columbia River and links Hood River with Bingen and White Salmon in Washington. The 4,418-foot-long bridge was built in 1924. (Photograph by D.C. Jesse Burkhardt.)

MOUNT HOOD YARD. With snow still dusting the distant hills on March 22, 1997, a freight train on Union Pacific's mainline rumbles past the Mount Hood Railroad's three-track yard at Hood River. The shortline's two 1950s-era GP9 locomotives—No. 88 and No. 89—are at rest in the yard, along with the sole caboose on the Mount Hood's roster and several passenger coaches. (Photograph by D.C. Jesse Burkhardt.)

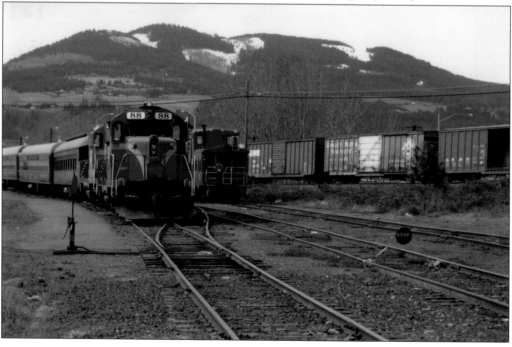

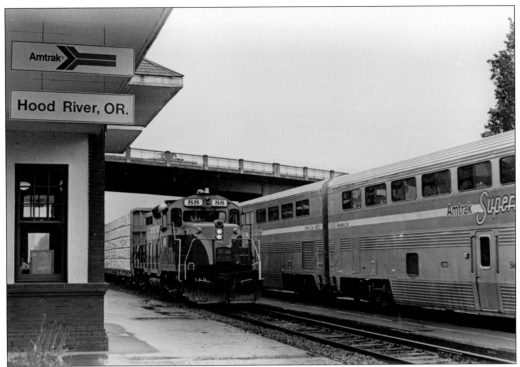

MEETING IN THE RAIN. During a hard rain in August 1995, Mount Hood No. 88 pulls two bulkhead flatcars of lumber past the combination Mount Hood Railroad/Amtrak depot at Hood River as Amtrak's westbound *Pioneer* passenger train pulls out of the station on its run to Portland. (Photograph by D.C. Jesse Burkhardt.)

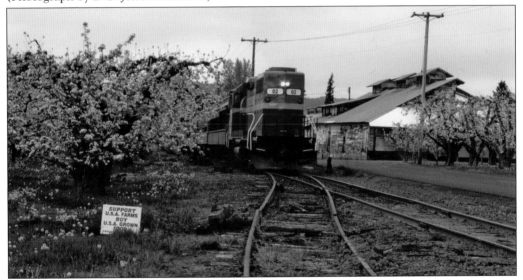

SUPPORT YOUR LOCAL FARMER. A Mount Hood Railroad tourist train bound for Parkdale cuts through an orchard in Pine Grove, Oregon—a community that relies on agriculture for its economic base. Note the sign posted alongside the tracks: "Support U.S.A. farms—buy U.S.A. grown food." In a stark reminder of changing times, the partially dismantled spur track in the foreground once served a fruit-packing warehouse. (Photograph by D.C. Jesse Burkhardt.)

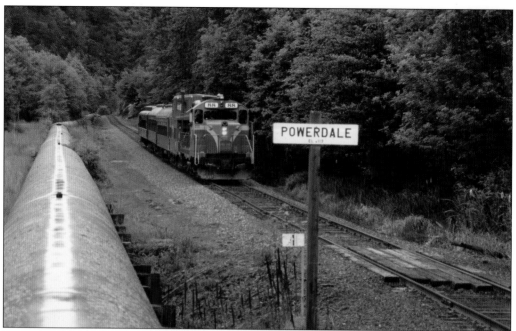

POWERDALE STATION. An excursion train comes down the tracks on May 27, 1998, passing a signpost for the Mount Hood Railroad station known as Powerdale. The station was named for the nearby Powerdale Dam, which was built in 1923 and removed in 2010. (Photograph by D.C. Jesse Burkhardt.)

VIEW FROM THE PIPELINE. Passengers gather on the rear car for a view of the scenery as an excursion train approaches Hood River on August 26, 2007. The water pipeline at right doubled as a unique trail for those willing to trust their balance on the metal surface. Sadly, most of the pipe was removed after Powerdale Dam was demolished. (Photograph by D.C. Jesse Burkhardt.)

RIVER OF PURPLE. Lupine blossoms add color to the hills south of Hood River on a foggy day in April 1997. The Mount Hood Railroad's dinner train, powered by American Locomotive Company (Alco) C415s No. 701 and No. 702, backs up the line after crossing the bridge over the Hood River. (Photograph by D.C. Jesse Burkhardt.)

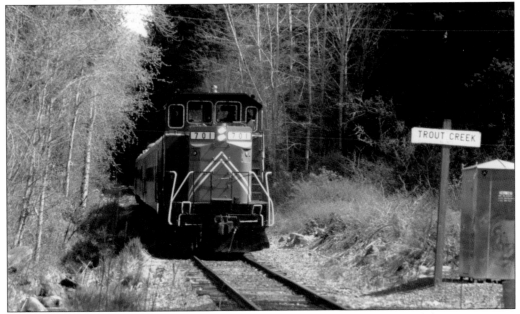

SOLO TRY. In April 1998, a single Alco C415 locomotive pulls the northbound dinner train past a new season's blossoms at Trout Creek, Oregon. The sound of Alcos in the Hood River Valley lasted for just over a year. By the end of 1998, the Mount Hood Railroad had sold both of its Alco units to another railroad. (Photograph by D.C. Jesse Burkhardt.)

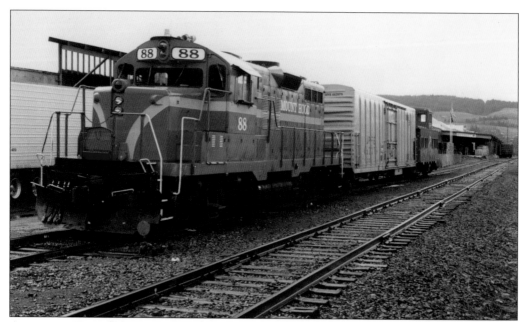

APPLES FOR EVERY SEASON. In this scene from a rainy day in March 1995, Mount Hood GP9 No. 88 idles in Odell, Oregon, while boxes of apples from the Duckwall-Pooley Fruit Company cold-storage warehouse are being loaded into a reefer. The shortline railroad also serves lumber and propane customers along its 21-mile line. (Photograph by D.C. Jesse Burkhardt.)

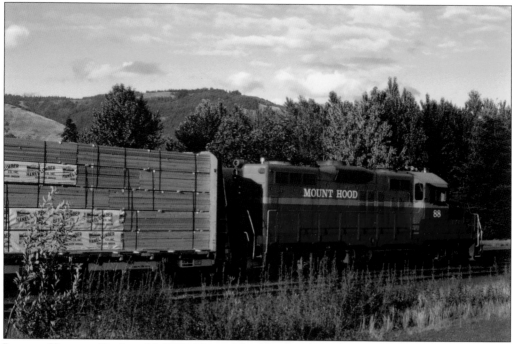

LUMBER HAULER. On June 14, 1995, Mount Hood Railroad No. 88 rests at its home base in Hood River with a cut of lumber cars from the Hanel Lumber Company. Despite the flowery look of the shortline's locomotive—and despite a focus on excursion trains—the railroad remains an active freight hauler. (Photograph by D.C. Jesse Burkhardt.)